Disclaimer

Due to the devastating floodwaters of Hurricane Camille in 1969, many of Pass Christian's treasured historic photographs were forever lost. The images within this volume represent what remains of the community's archives.

It should be noted that these photographs were scanned by the author and not the publisher. The publisher therefore is not responsible for the quality of the photo reproduction.

IMAGES of America
PASS CHRISTIAN

Dan Ellis

Copyright © 2001 by Dan Ellis
ISBN 978-0-7385-1360-7

Published by Arcadia Publishing,
Charleston, SC, Chicago, IL, Portsmouth, NH, San Francisco, CA

Printed in the United States of America

Library of Congress Catalog Card Number: 2001089787

For all general information contact Arcadia Publishing at:
Telephone 843-853-2070
Fax 843-853-0044
E-Mail sales@arcadiapublishing.com
For customer service and orders:
Toll-Free 1-888-313-2665

Visit us on the Internet at www.arcadiapublishing.com

CONTENTS

Acknowledgments 6

Introduction 7

1. Annual Events 9
2. Community Heritage 37
3. Historic District 89
4. Hurricane Camille 97
5. Church and School 103
6. Henderson's Point 111
7. DeLisle at the Bayou 121

ACKNOWLEDGMENTS

Billy Bourdin's Historical Collection has been a tribute to heritage preservation in the 300-year-old community of Pass Christian. It is a credit to Billy Bourdin that this book was made possible.

Upon walking into the Bourdin Plumbers Shop in the middle of town, one is confronted by a maze of photographs that tells a story about the beautiful Gulf Coast resort town where Billy Bourdin was born and spent all of his life. His collection started after the devastation of Hurricane Camille in 1969. Not only was most of the city destroyed, but so were most of its heritage documents and city records. Billy Bourdin, now retired, has accumulated more than 3,000 graphic representations of Pass Christian and the neighboring areas. Most of his days are spent clipping and copying from old newspapers, some more than 100 years old. He has cataloged these snippets of history into nearly 500 categories by events, persons, homes, and buildings.

As past memories fade for some, Bourdin clearly recalls the many landmarks that no longer exist. Bourdin keeps alive all of the happenings that have passed through the eras of time.

Introduction

Pass Christian is situated on a peninsula like many other Gulf Coast resorts. The town has essentially contained itself within its current city limits for more than a hundred years, having a six-mile frontage on the Mississippi Gulf Coast. On the west is the Bay of St. Louis and at the city's north are the bayous of Boisdore (Bois d'Ore) and Portage, named by early French explorers in 1699. Pass Christian is pronounced with the accent on the last syllable (christy-Anne) and was named for Nicholas Christian Ladner who settled at nearby Cat Island in 1745, naming the channel pass for himself. Later, the town followed suit. The Pass, as it is often called, became one of the early port towns to have schooner access to New Orleans. As years went by, New Orleanians adopted the Pass and its surrounding areas as resort spas for second residences. This lifestyle custom has prevailed for the past 150 years, and many of the Pass residents continue to vote elsewhere.

The Pass is famous for its 300-year-history through French, English, and Spanish domination until the American flag was raised in 1811. Following its incorporation in 1848, hundreds of cottages were built along its coastline—many still remain with architectural styles that include Greek Revival, Queen Anne, and local vernacular Creole. Many of these stately mansions and cottages were built by wealthy Orleanians when the Mississippi Coast was considered their exclusive playground. Before the Civil War, architects were hired to redesign the homes and converted many of them to Colonial Revival styling.

With the completion of the Illinois Central Railroad in 1925, many Northerners began to take pilgrimages to the Gulf Coast. With the increased traffic of "snowbirds," coastal restaurants started posting signs that stated, "We Serve Northern Coffee," in contrast to the chicory coffee that Southerners had adopted since the Civil War.

Since the mid-1950s, the city has been home to a population variance of 5,000 to 6,000 and has continued to maintain its maritime presence. Just offshore are nine large oyster reefs that accommodate large dredging vessels as well as small skiffs with one or two fishermen. These men tong for oysters using two rakes that operate like scissors, dislodging oysters from the top of shallow shell reefs. A seafood cannery was in operation in the Pass from 1902 to 1947. Since the cannery closing, most of the oysters are taken to nearby Biloxi where large automated shucking machines are located. During the shrimping season, hundreds of boats arrive from Alabama to Texas to trawl offshore. The abundant shrimp catches are processed locally as well as transported elsewhere.

The Pass Christian harbor brings together a wonderful display at the beach, where tied up at its berths are a mixture of commercial ships, sailing crafts, and pleasure launches. Popular water sports include sailing, skiing, fishing, flounder spearing, net casting, swimming, beach wading, and island hopping. Besides the Gulf of Mexico, there is also the offshore Sound that is protected by barrier islands, and bays, bayous, rivers, and streams abound in the area. Pass Christian is also noted as the birthplace of Southern yachting. The second yacht club (New York City had the first) was created here in 1849, when competitive sailing regattas were organized at the Pass Christian Hotel.

Following Hurricane Camille's great devastation in 1969, the Pass Christian Historic District was promoted in order to protect the quality and architecture of surviving homes and homesites. Now listed on the National Register of Historic Places are more than 120 dwellings and buildings whose owners must adhere to rigid standards to protect these treasures from distorted remodeling.

One
ANNUAL EVENTS

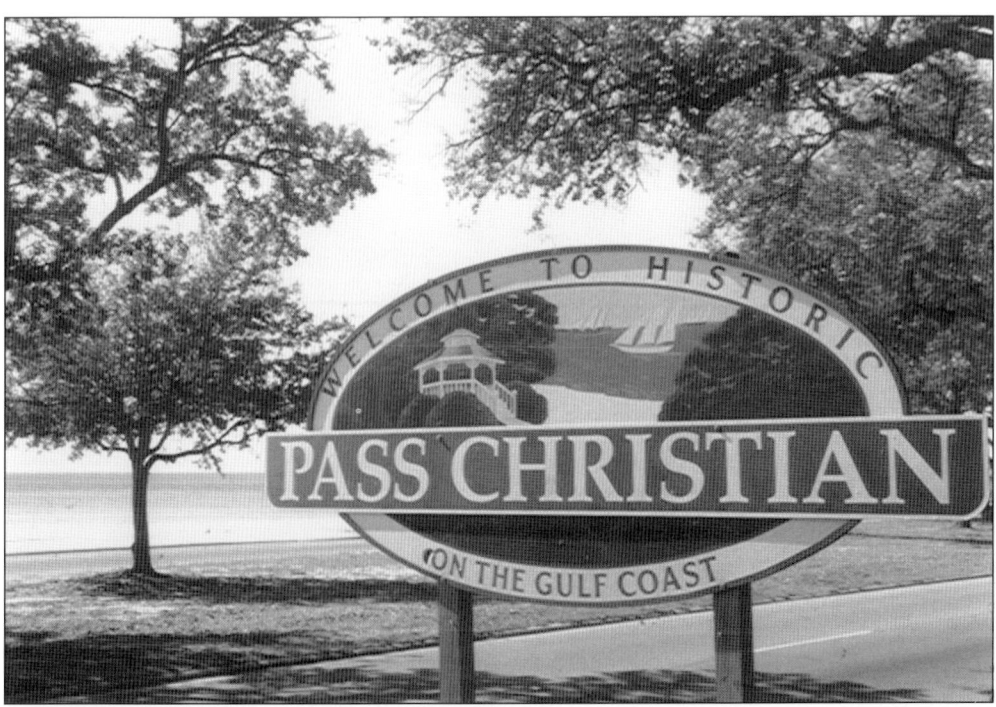

Pass Christian, one of the smallest cities along the Mississippi Gulf, has a proud heritage resulting from 300 years of a distinctive lifestyle. The city has maintained a steady population of between 5,000 and 6,000 people; however, in spite of its small size, the Pass has numerous annual events that draw many visitors and tourists. Pass Christian's Mardi Gras multiplies the city to an estimated 60,000 paradegoers. A number of other events attract 4,000 to 7,000 participants, including the following: racing regattas, Mardi Gras, St. Patrick's Day, the Blessing of the Fleet, "Celebrate the Gulf," "The Collage," "Toast the Coast," "Jazz in the Pass," the Seafood Festival, and "Christmas in the Pass."

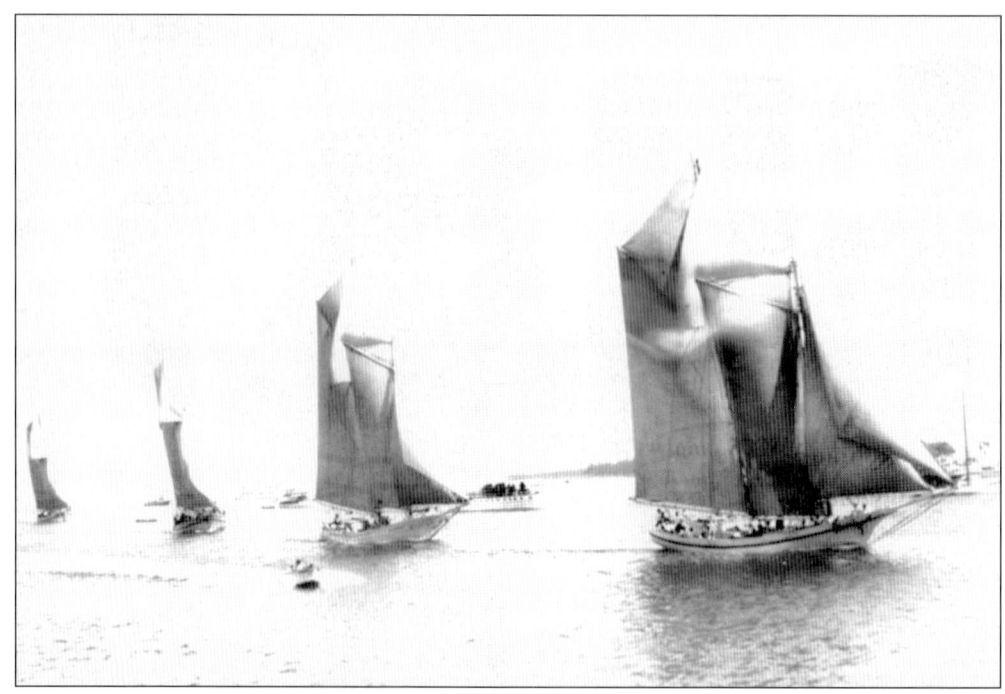

Racing regattas started in 1849. By the 1920s, seafood canneries and packing companies were becoming prevalent in the area and many company-owned fishing schooners were entered into the competitions. The *Mary*, owned by the Aticich Canning Company, is shown here in the lead.

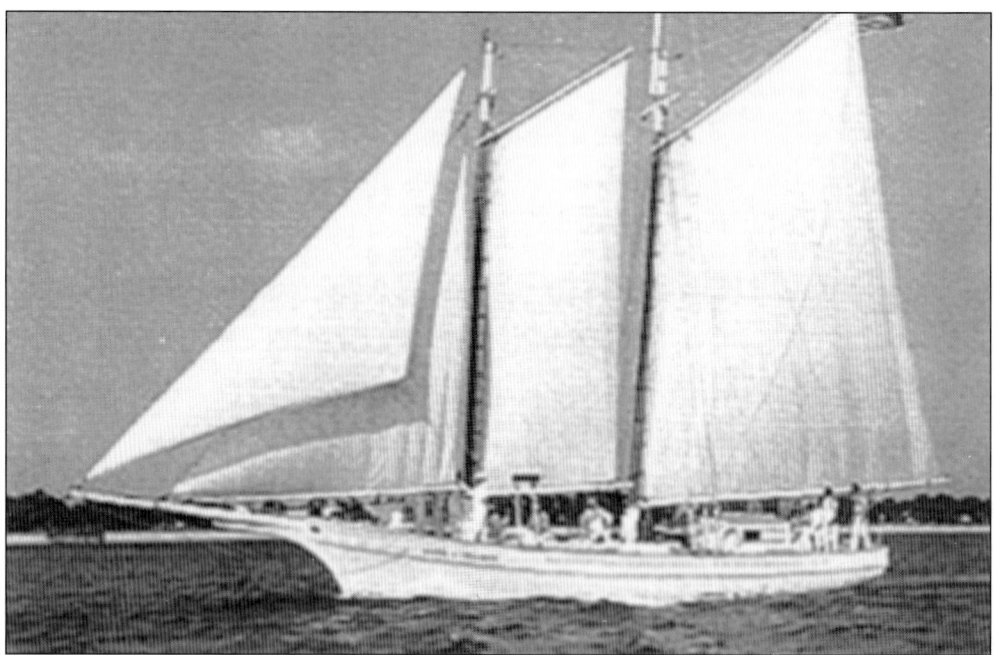

Vessels with new sleek designs that cruised the Mississippi Sound waters in elegant swiftness replaced the old masted schooners. The Yacht Club sponsored sail racing in the Sound and at the city's northern boundary, and motorboat races were organized in Bayou Portage.

Competing against 24 other teams, Pass sailors celebrated winning the 74th Annual Lipton Regatta on Labor Day in 1993. The win assured the Pass Christian Yacht Club the distinct honor of hosting the Diamond Jubilee Lipton Regatta the following year.

In 1937, the Yacht Club was reorganized with Bernard Knost installed as its commodore. Interested female skippers were inducted into the Skipperette Club, thereby initiating the first annual Knost Regatta the following year. The Knost Regatta has challenged female sailors ever since. Sailing preparations are shown here.

Getting set with their rigging, the Skipperettes mount their masts and sails as they move their hulls to the water launch. They are always assured of a spirited audience and look forward to participating in the award celebrations that follow the race.

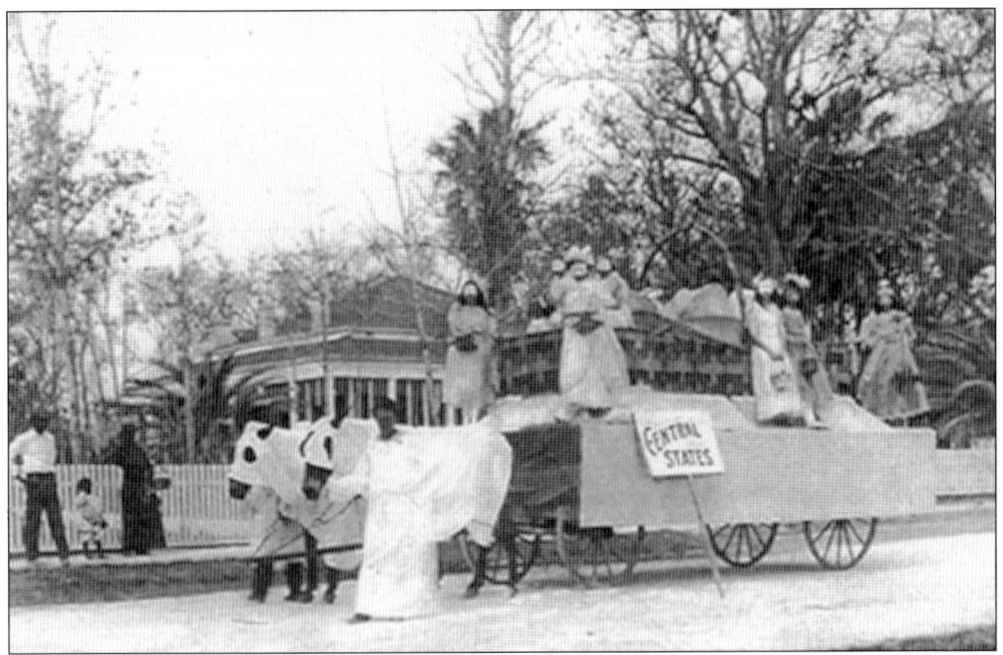

Mardi Gras in 1913 was celebrated with 10 floats decorated to represent different geographic locales. This was the Pass Christian float, which displayed Mermaids of the Sound. Mules were used to pull garbage wagons that were cleaned and covered with shiny new materials.

This 1913 Mardi Gras float represented the Central States. Mule-powered wagons were escorted by drivers who walked along holding onto the reins and harnesses.

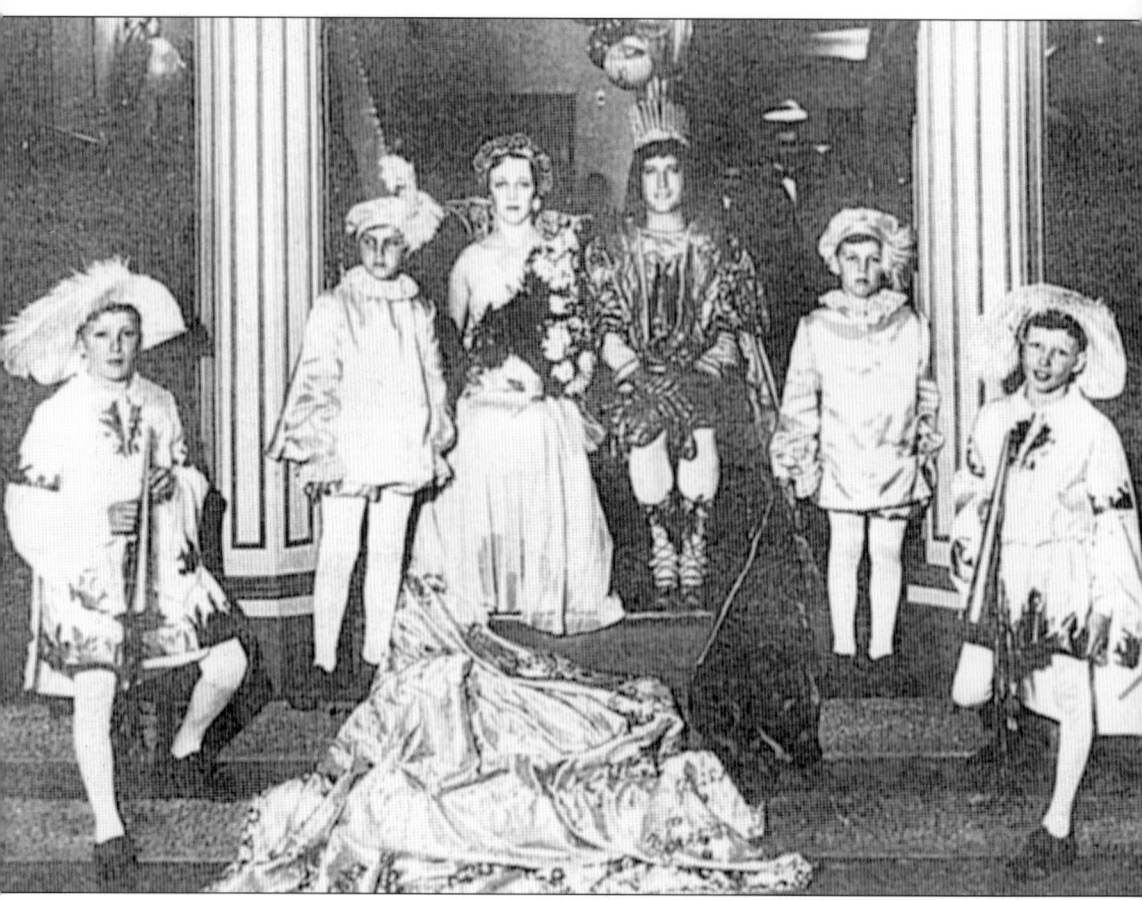

Pass Christian Mardi Gras royalty originated with the idea that an all-male Krewe would be chosen and cast as king, queen, and the royal court. The first king and queen designates were Messrs. Louis Martin as King Arthur and Henry Roux as his queen, but Roux backed out at the last moment and was replaced by Miss Ellen Courtenay. Shown here are Julius J. Hayden and Forest Spring Hayden as King Author II and his queen in 1916.

The earliest Pass Mardi Gras was interrupted by World War I and was reorganized in 1930 as a fund-raiser for St. Joseph School (now St. Paul School). The event has been in continuous performance ever since. Shown in 1931 is Miss Emilie Farrell, Queen Christina.

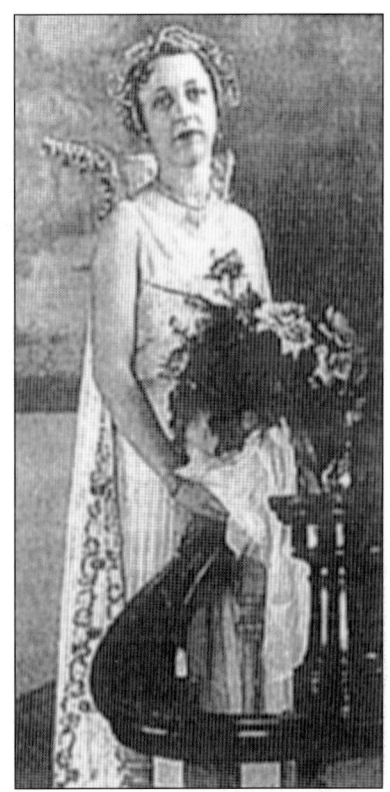

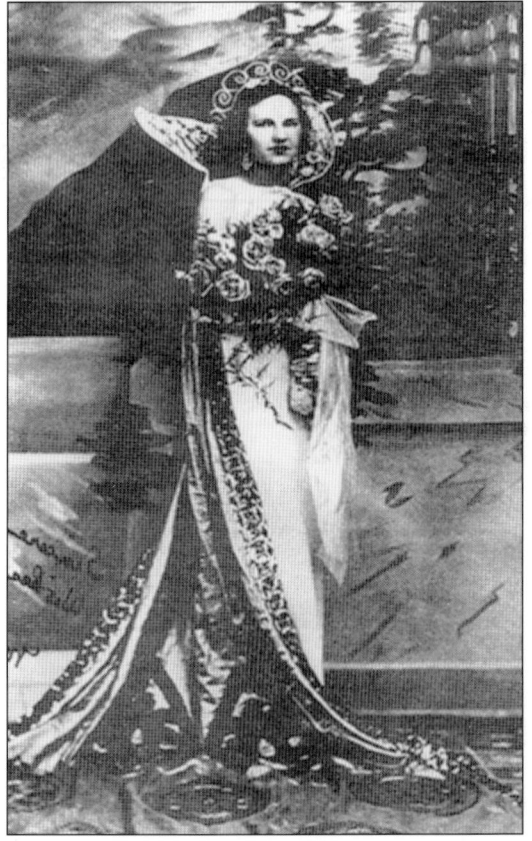

School parents found that competing teams seeking the cherished royal positions were able to raise more money. This meant earlier planning of dinners, contests, and ticket sales within the community to promote the king and queen and designated court members. Shown here is 1934's Queen Myrtle, Spence McDermott. The Grand Ball was held at the Grey Castle Hotel, which is no longer in existence.

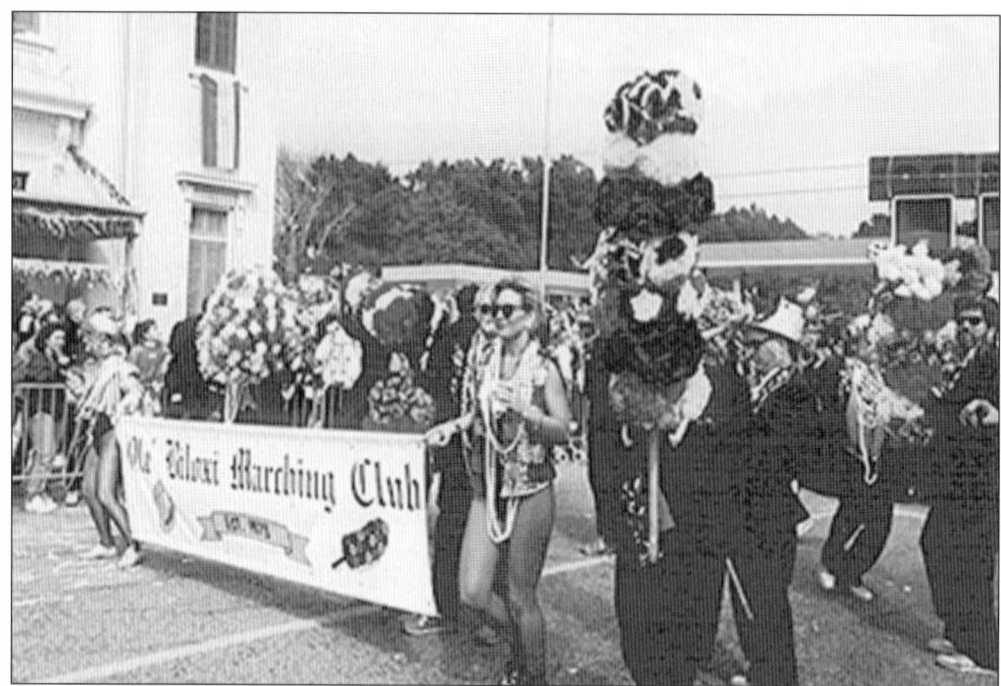

The Pass Christian parade is the biggest on the Gulf Coast, billed with as many as 80 floats and many bands and walking groups. Shown above is the Biloxi Marching Club passing in front of Hancock Bank on Scenic Drive.

"Throw me something, Mister," is the favorite scream used to encourage masked float riders to throw beads, cups, medallions, whistles, canes, etc. to those in the crowd. Youngsters are held up in out-stretched arms to get their share of goodies.

In 1995, Mardi Gras's King Christian was Rep. Jim Simpson. The King's float always attracts much attention because of his attire and majestic regalia.

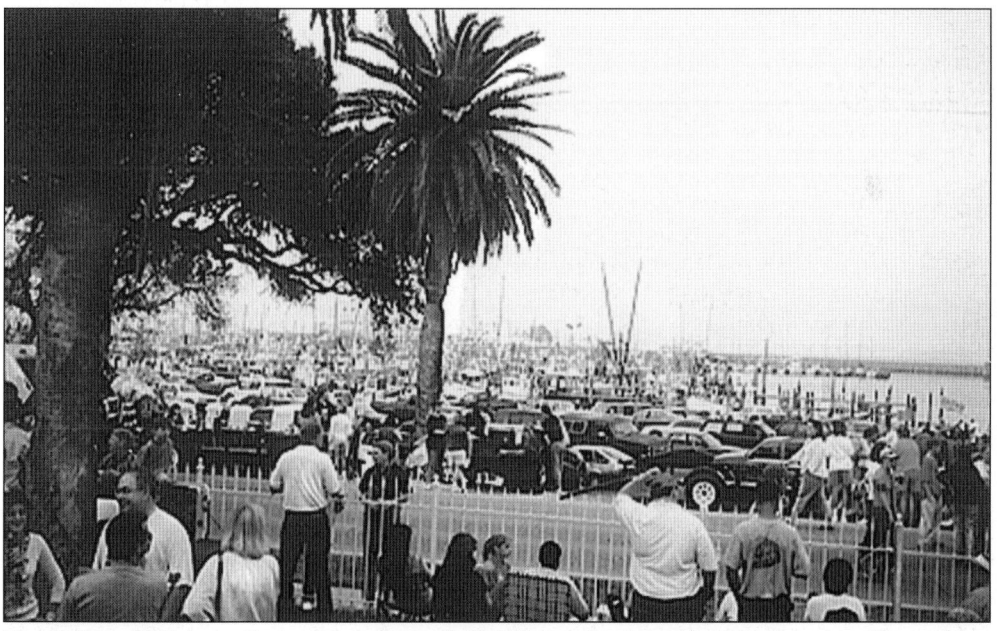

Mardi Gras 2001 brought out an estimated 60,000 people along the parade route. Shown here are early revelers who started gathering on Highway 90, facing the Pass Christian Harbor. Many people start gathering hours before the parade and some even camp out the night before in order to secure the most desirable viewing location.

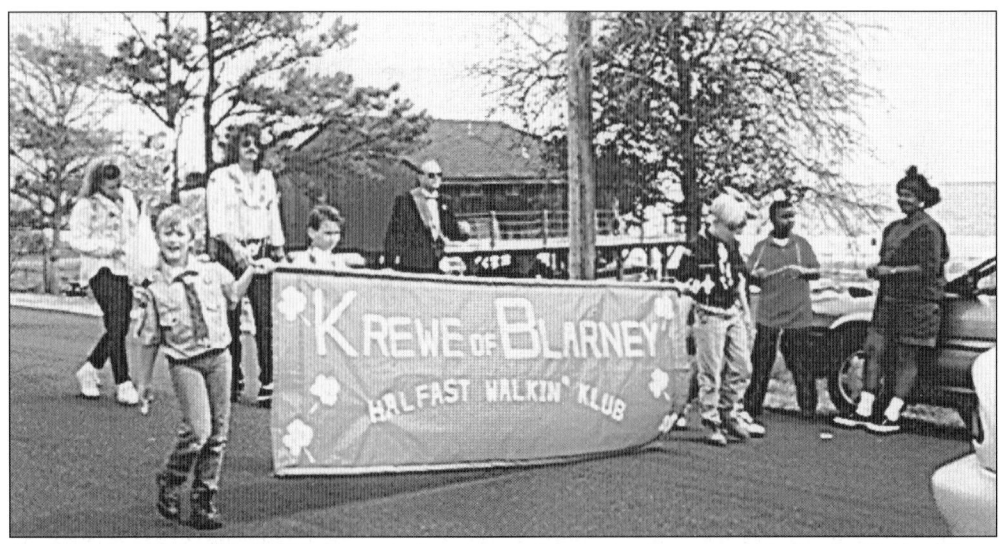

St. Patrick's Day in Pass Christian is also unique because it has the only St. Paddy's walking parade on the Coast. Patterned after Pete Fountain's Half Fast Walking Organization, the Krewe of Blarney is called the Halfast Walkin' Klub and was organized in 1995.

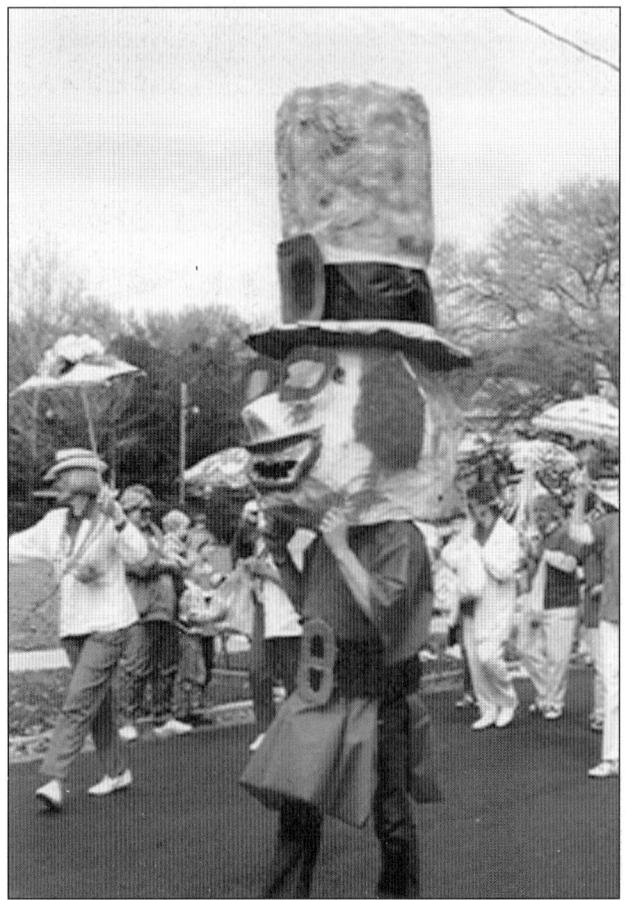

An anonymous local celebrity is always chosen to don the leprechaun outfit and masking. Those who have the most fun are usually the ones who are normally straight-laced in public. The lightheaded papier-mâché mask towers above the crowd.

St. Paddy's in the Pass uses elected officials as grand marshals. From left to right are State Rep. Jim Simpson; Bob Bass, mayor of the City of Long Beach; Corene Lewis as Colleen; and Grand Marshall Marlin Ladner, county supervisor.

The St. Paddy's Halfast Walkin' Klub warms up at its Rendezvous Toasting Party before the start of the parade. Shown here is parader Jennie Lou Mintz making her special requests to the imported New Orleans jazz band.

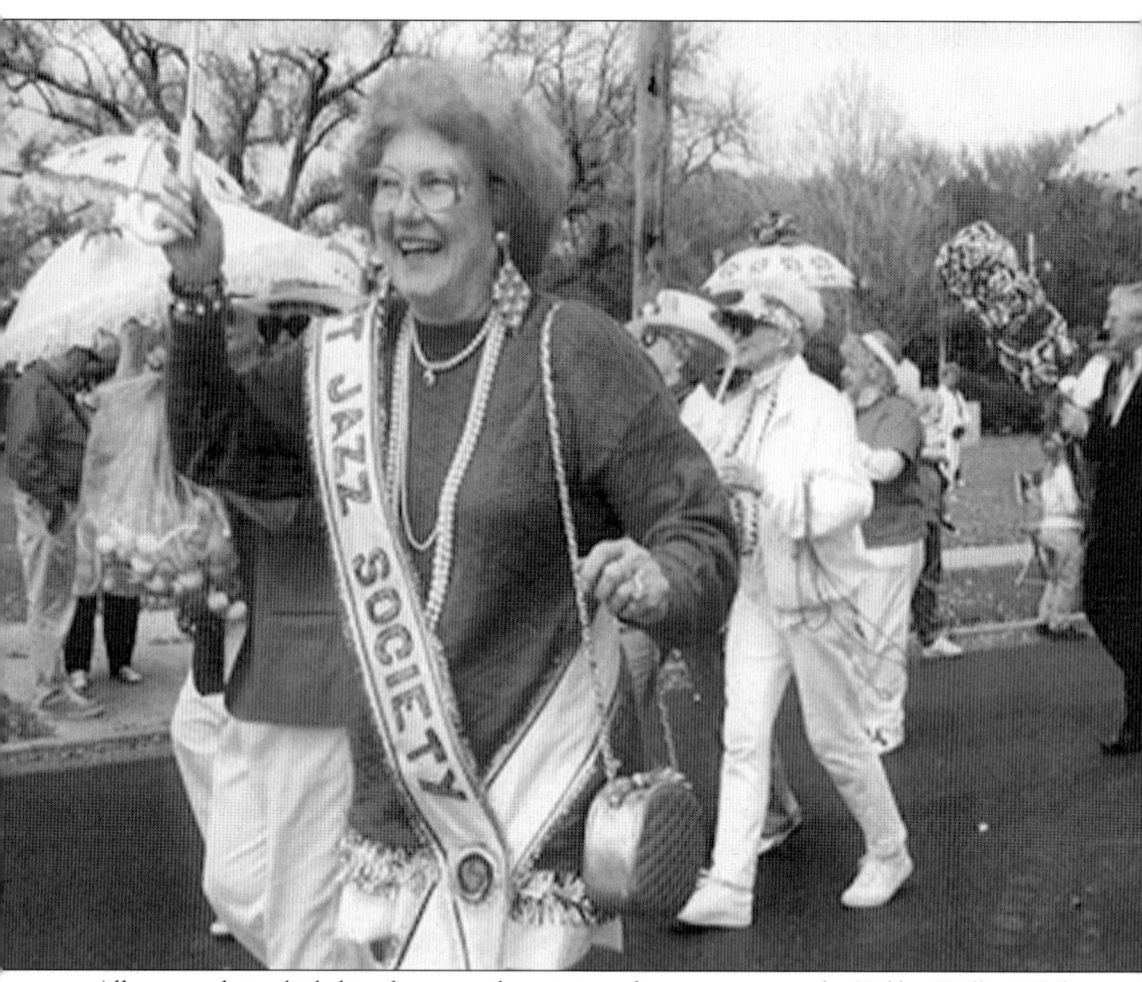

All one needs is a little bit of green and a grin in order to step out in the Halfast Walkin' Klub. From all over the Coast, strutters join in to take three steps forward and two steps back in rhythm with the tunes of Irish jigs.

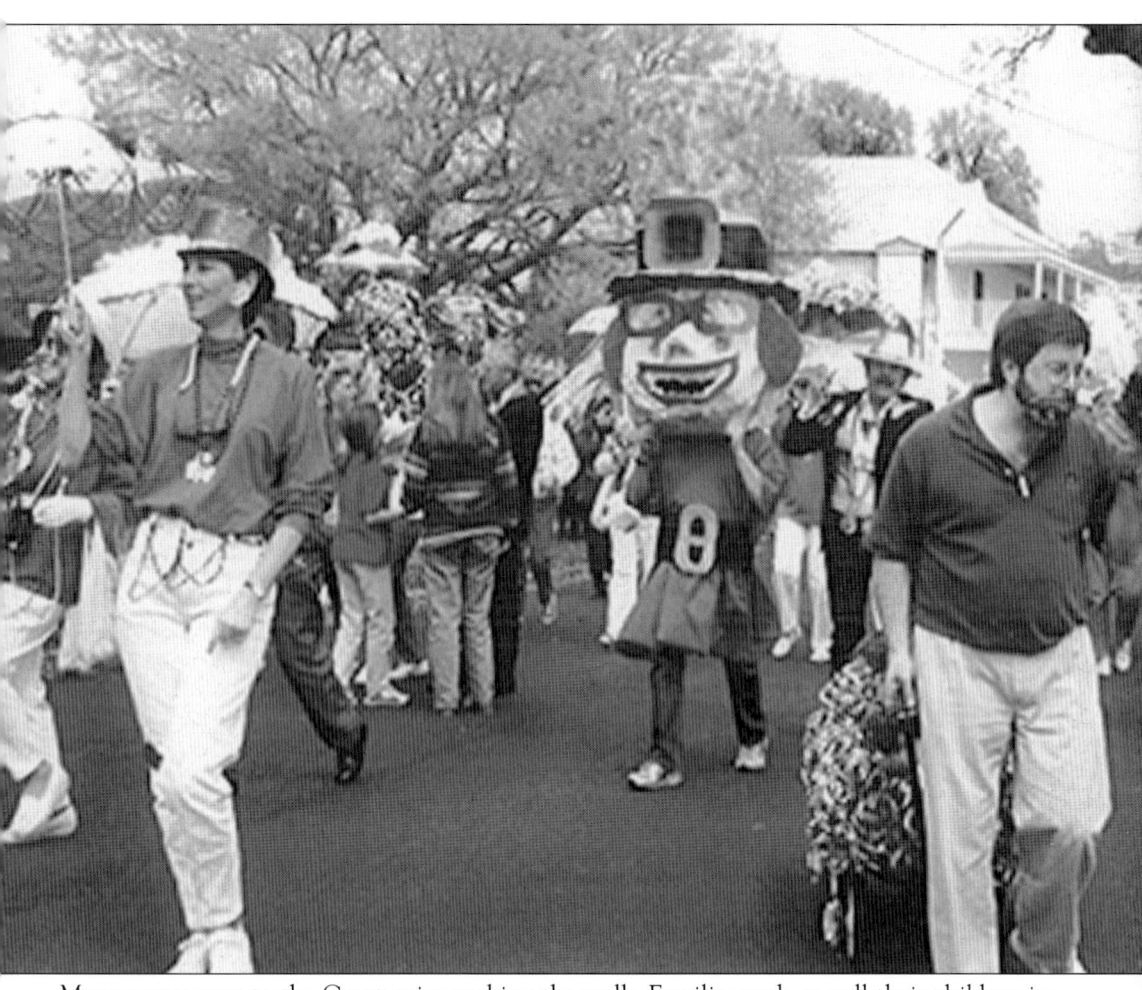

Many newcomers to the Coast enjoy making the walk. Families push or pull their children in carts and wagons as they carry beads or flowers to pass out to parade watchers.

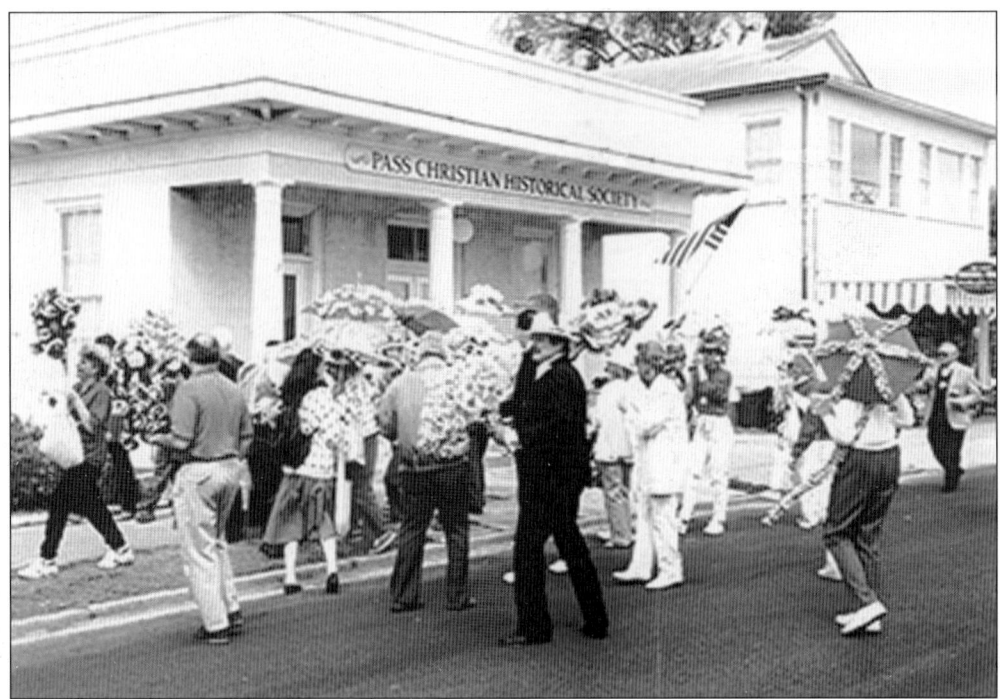

Several stops are made along the way where the Grand Marshal and his entourage of tuxedo-clad VIPs are furnished plastic cups with varying beverages to make grand toasts to the memory of fine old Saint Pat.

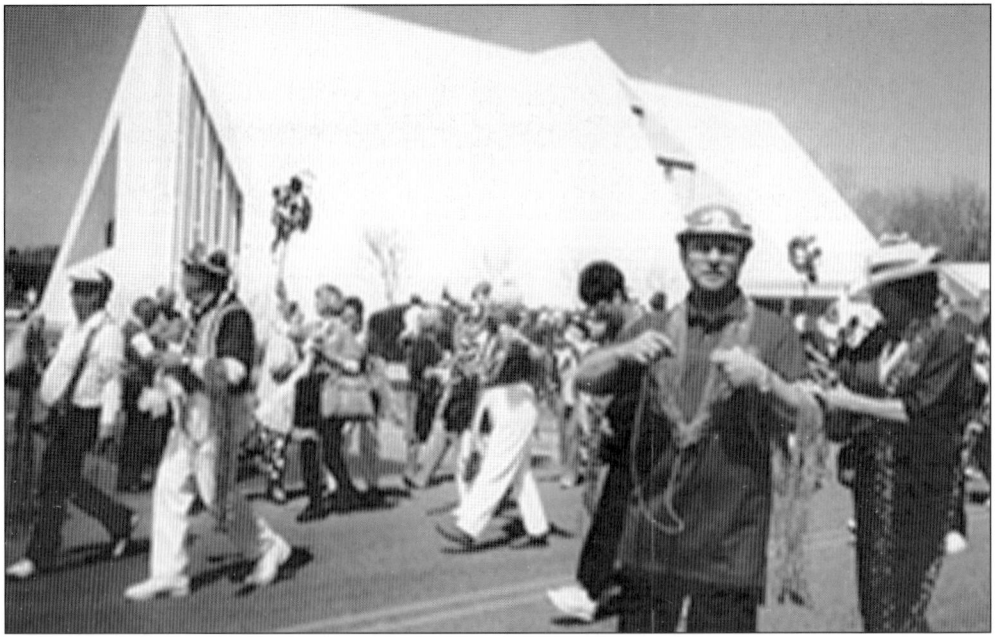

One highlight for the marchers is a stop at city hall where the Special Olympics kids wait to exchange their special hugs and beads. A second significant stop is at the Miramar Nursing Lodge where nearly a hundred senior citizens await the marchers in wheelchairs. Marching bands also serenade the viewers at these two stops.

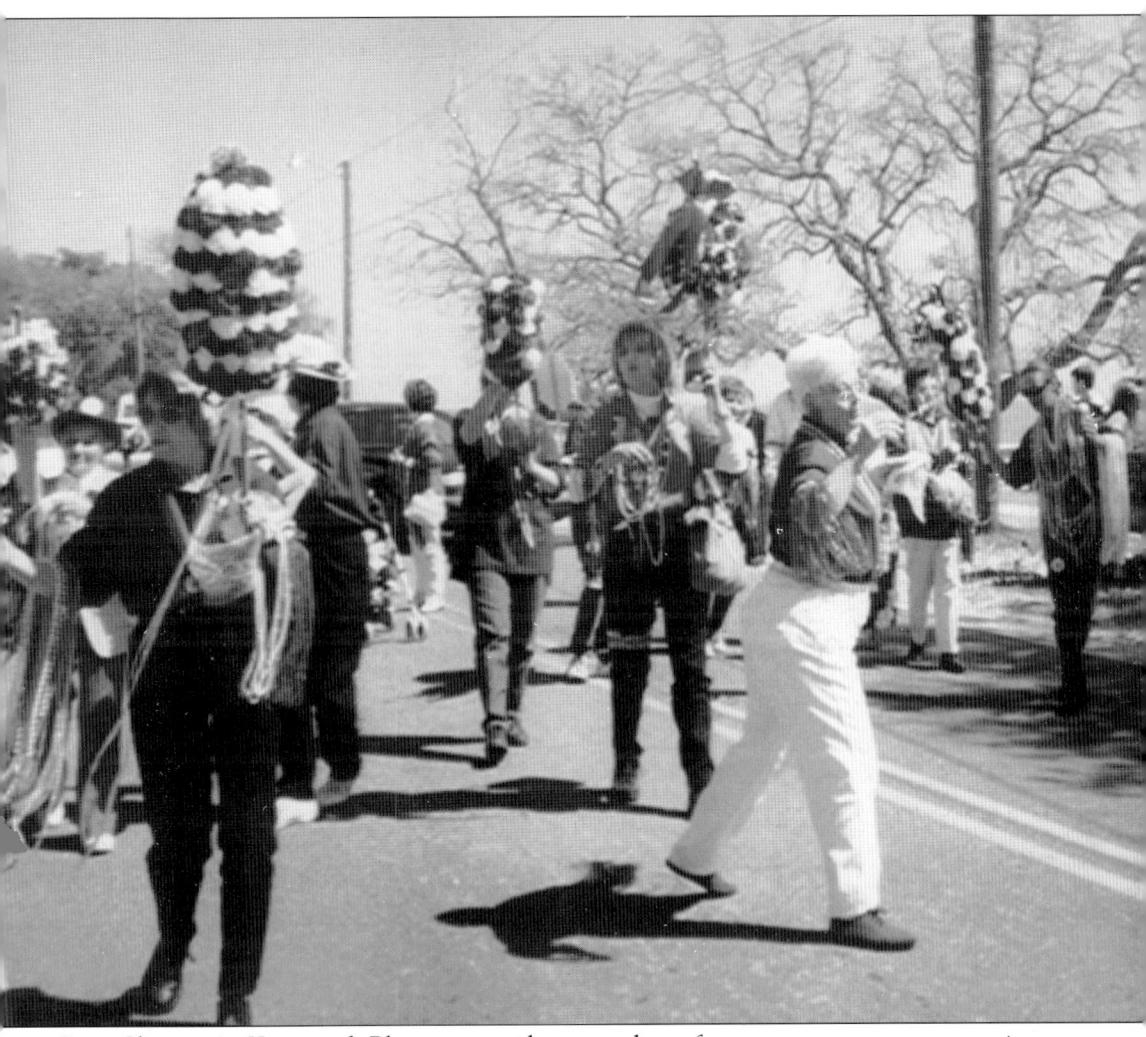

Pass Christian's Krewe of Blarney provides one day of zest as a temporary reprieve from the Lenten season that follows the Mardi Gras parades. The parade does not allow floats to participate but does encourage decorated golf carts to follow at the end of the parade line.

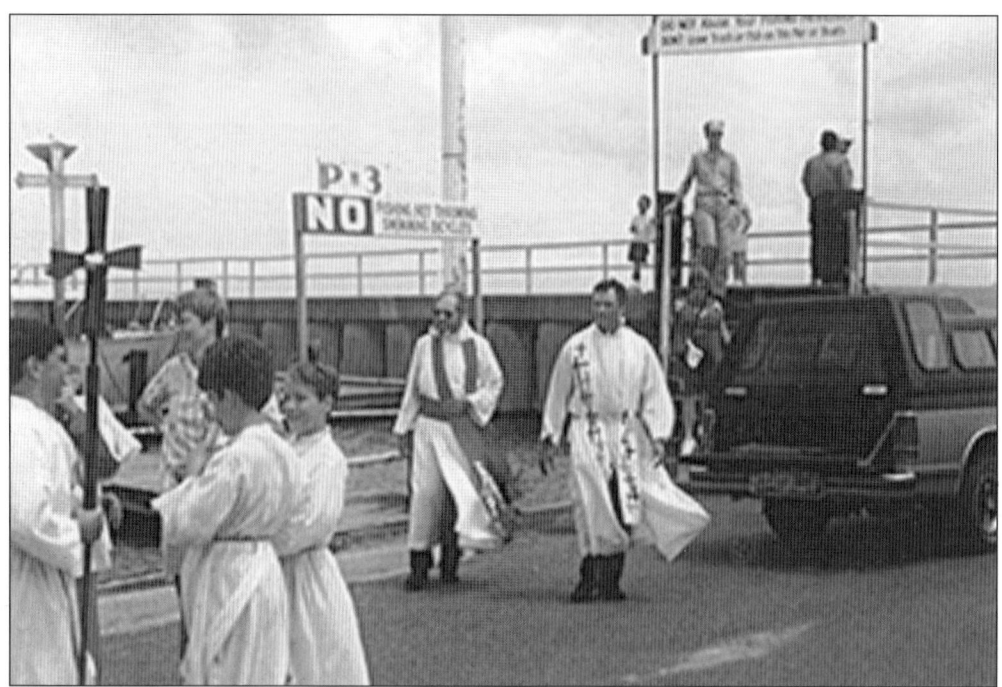

The Blessing of the Fleet is a special annual rite in maritime communities that is usually held in May. These two priests, gathered with their respective altar boys, are Rev. Bill Buice of Trinity Episcopal Church (left, rear) and Father Ron of St. Paul Catholic Church (right).

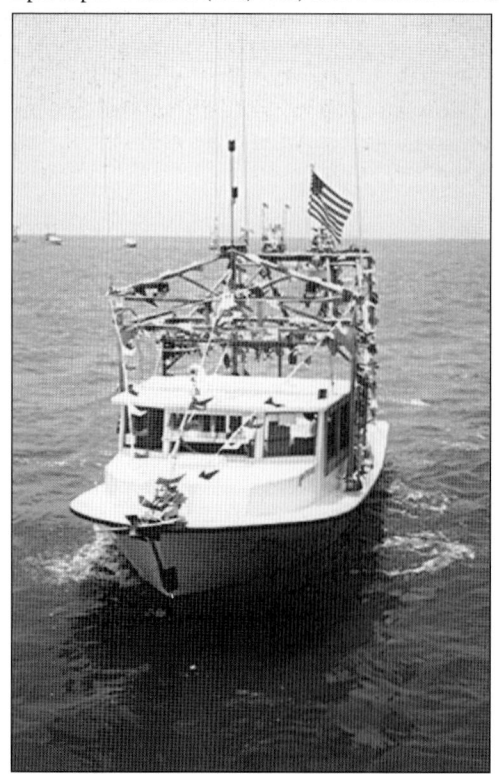

The Blessing of the Fleet not only brings out commercial fishers but also pleasure boat owners. Prizes are given to the best-decorated boats in various class categories. It is customary for the boats to line up in parade fashion to pass by the blessing vessel. As the priests bless each boat, judges take note of the finalists.

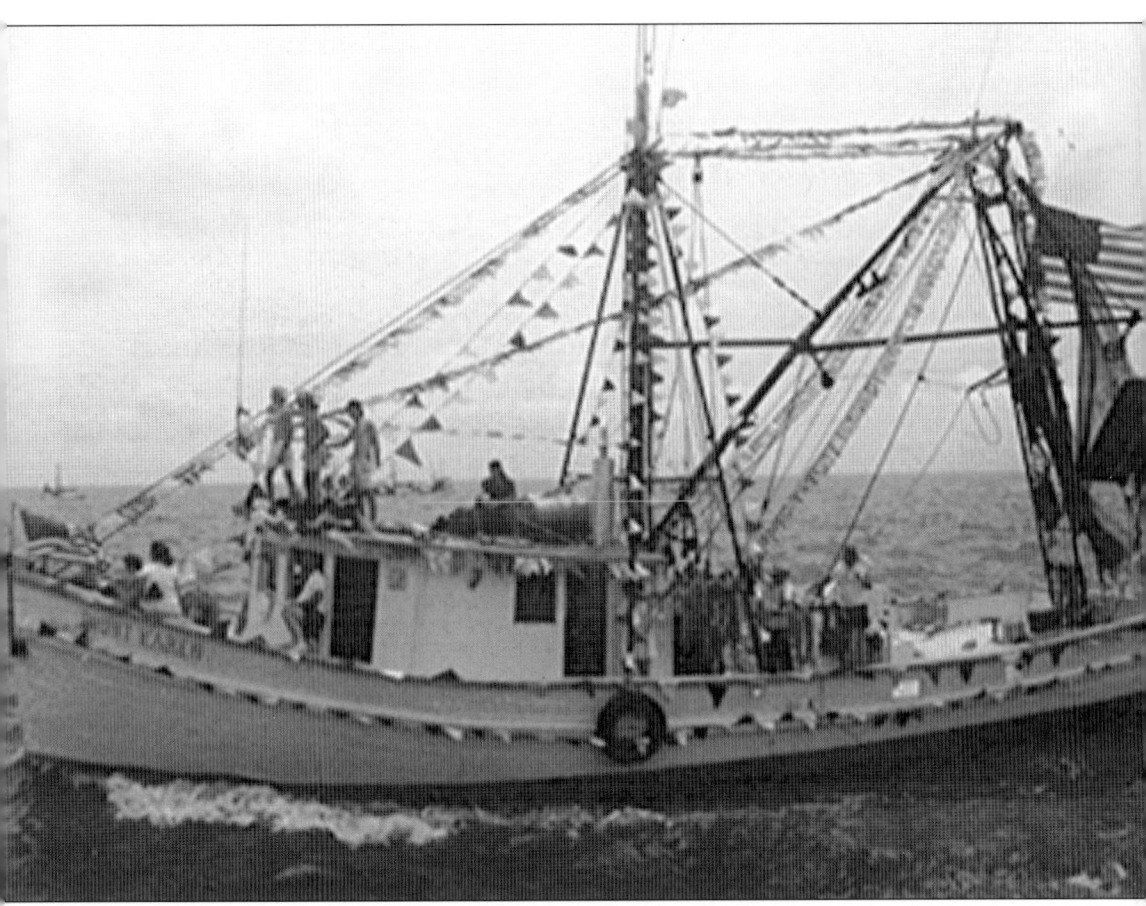
People living on the Coast are proud of their American flag, displaying it not only on poles in front of their homes but also on most of the boats that pass by for blessings and contest awards.

The Pass Christian Harbor is the finest on the Coast; it can be seen alongside Highway 90. Here is a large skiff with its trawling rigging emblazoned with flags and decorations.

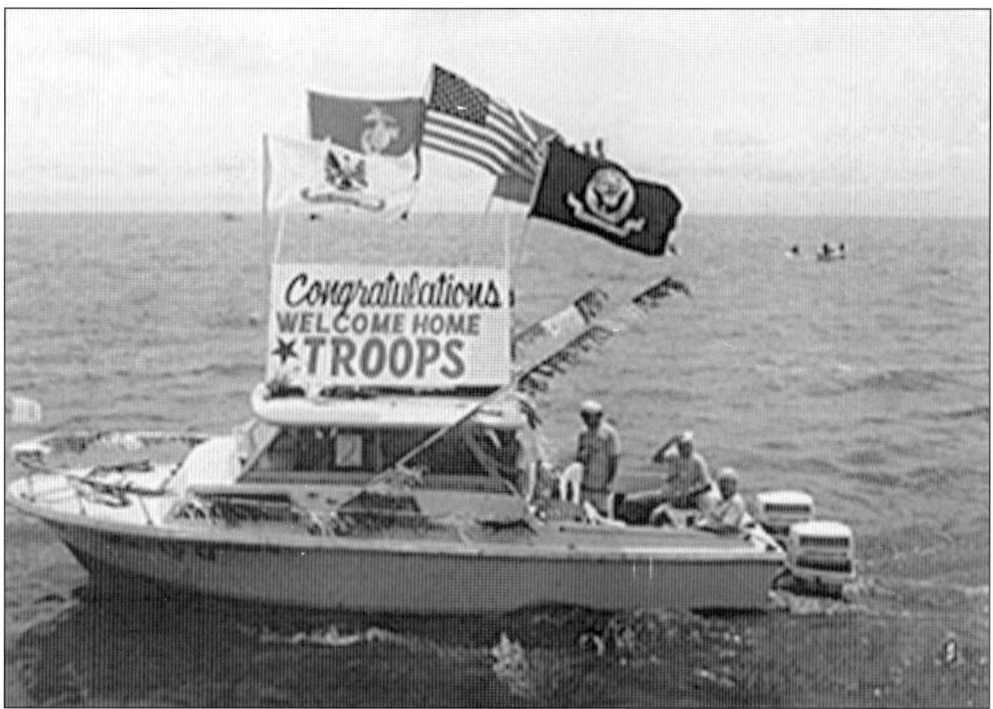

Welcoming home the military from the Gulf War of 1990, this boat is decked out in festive patriotic colors with a sign to welcome the troops. With the many military install personnel.

26

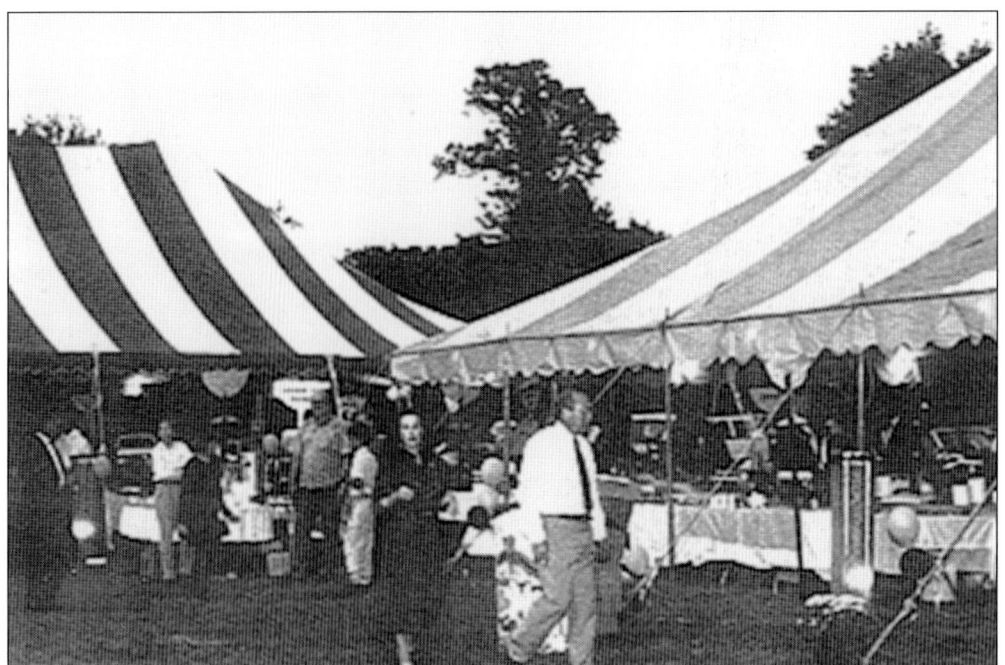

Celebrate the Gulf is an innovative program that originated in Pass Christian. Sometimes simply called "The Celebrate," it is a medium for many maritime-oriented institutions, agencies, and industries to gather under separate tents to show their products or specimens and to provide educational material. "Hands on" experiences are offered to young children.

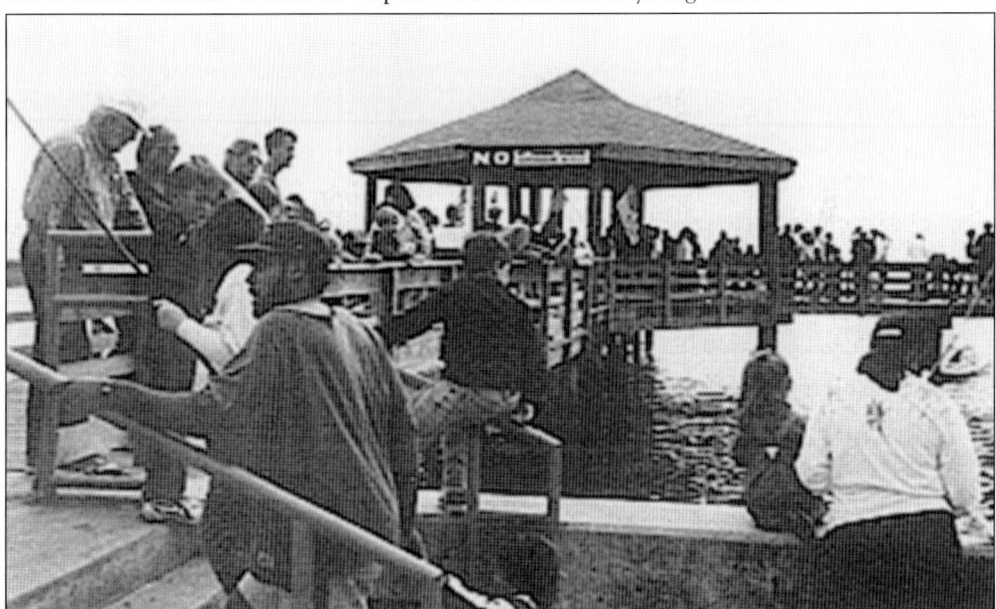

Celebrate the Gulf promotes a Kiddy Fishing Rodeo where youngsters are given fishing poles and bait and are escorted by their parents to the fishing pier. Prizes are given for varying fish catches. While at the water's edge there are also many exhibits including Dive and Rescue Squad drills. All fishes caught were put in a holding tank and later released back into the Sound as an example of recycling, touted as "Catch and Release."

"Collage Weekend" is an artist's paradise, where a variety of arts and crafts are exhibited, bought, and sold. Many of the artists participate in the event only for appreciation and with no intent of making a sale. Each exhibitor is provided with a tent in which to display their artwork.

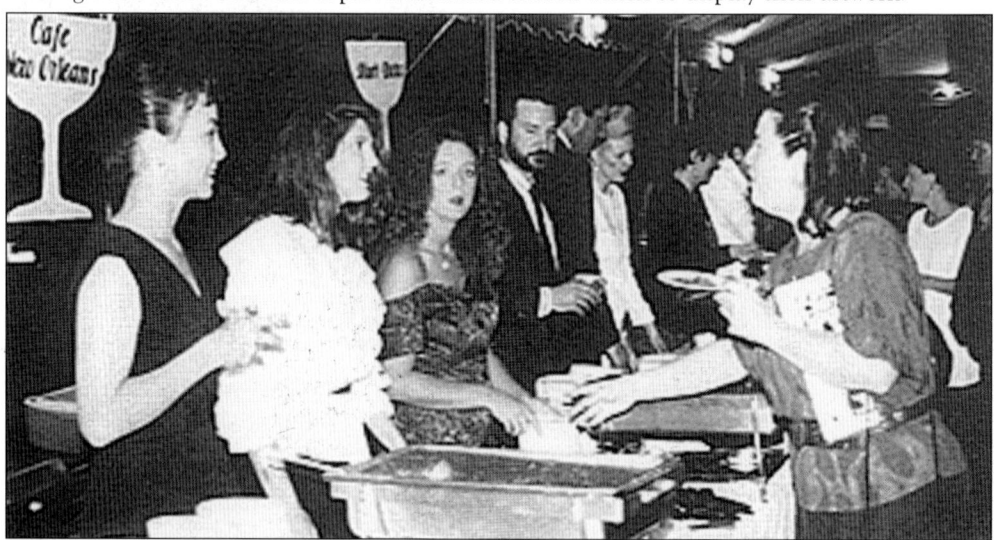

Food tents are also set up in Memorial Park where those in attendance are serenaded with music. "Toast the Coast" is a unique display of culinary and fine arts that has brought together more than 1,000 participants since its inception in 1983. The Coast's top chefs—more than 50—gather for this special annual fund-raiser to benefit the Coast Episcopal schools. Top artists donate works that are displayed for a silent auction.

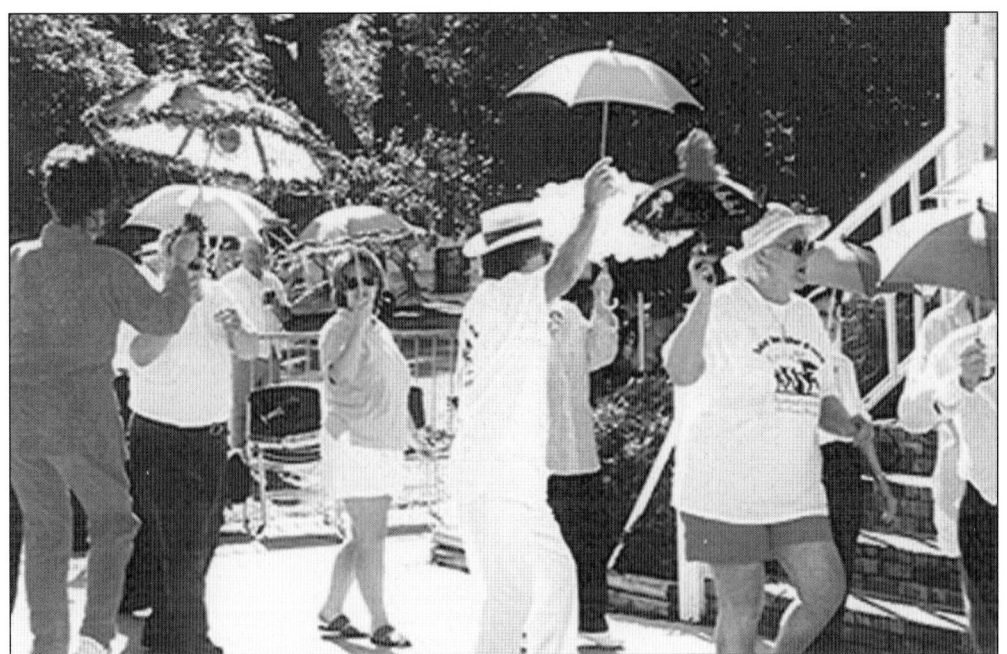

"Jazz in the Pass" was initiated in 1999 at a celebration of the Coast's tricentennial. Because Pass Christian has a rich musical heritage and has produced many early jazz celebrities, the event was dedicated in their memory.

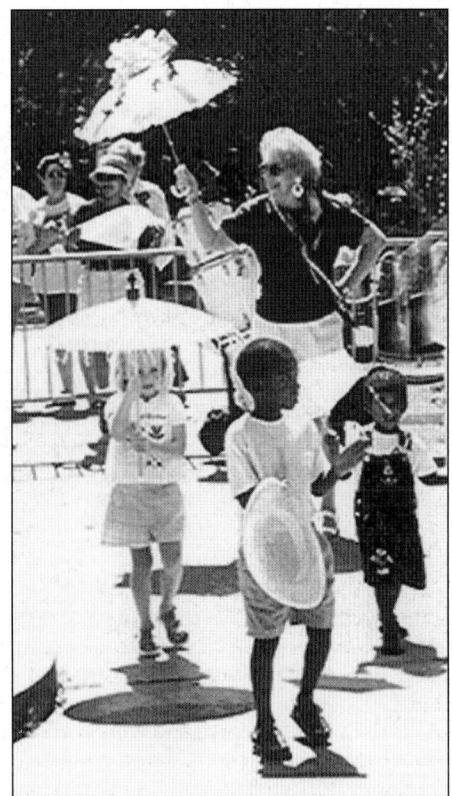

Jazz in the Pass not only brought together local and imported bands, but many local citizens lived it up by "second lining" with their handmade umbrellas. Even the youngsters were encouraged to get up and dance.

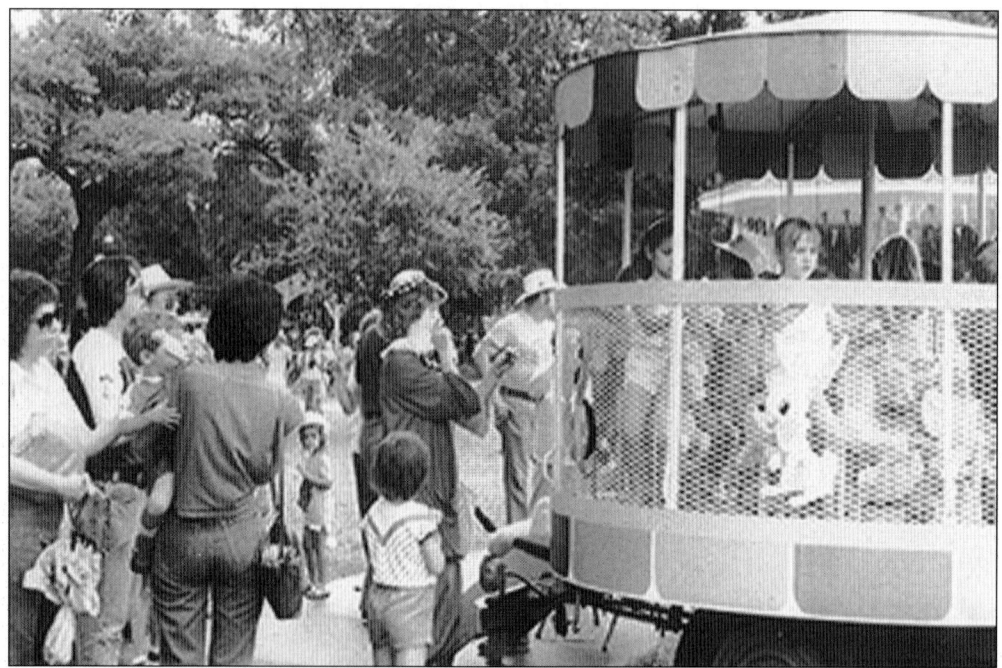

The annual Seafood Festival is held during the opening of the shrimping season. Besides great food, the festival boasts a carnival atmosphere complete with rides such as this carousel—keeping kids occupied while parents seek out locally prepared seafood dishes.

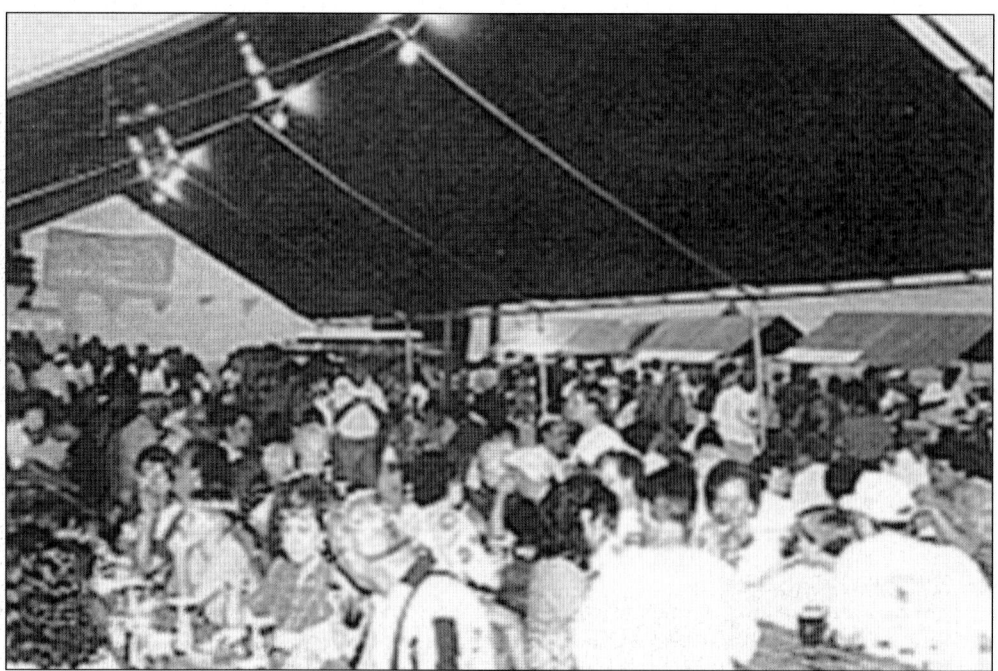

With live music is in the air, visitors and locals dodge the heat of the sun beneath live oak trees or gather in large tents that accommodate hundreds at a time. The food is ample and includes gumbo, crab, and shrimp—boiled, fried, or prepared in a variety of menu selections.

To close out the year's events, Pass Christian merchants sponsor a large downtown open-house party. All the streets are barricaded on the first Friday of December and become filled with people promenading in open malls and visiting the open houses along the way.

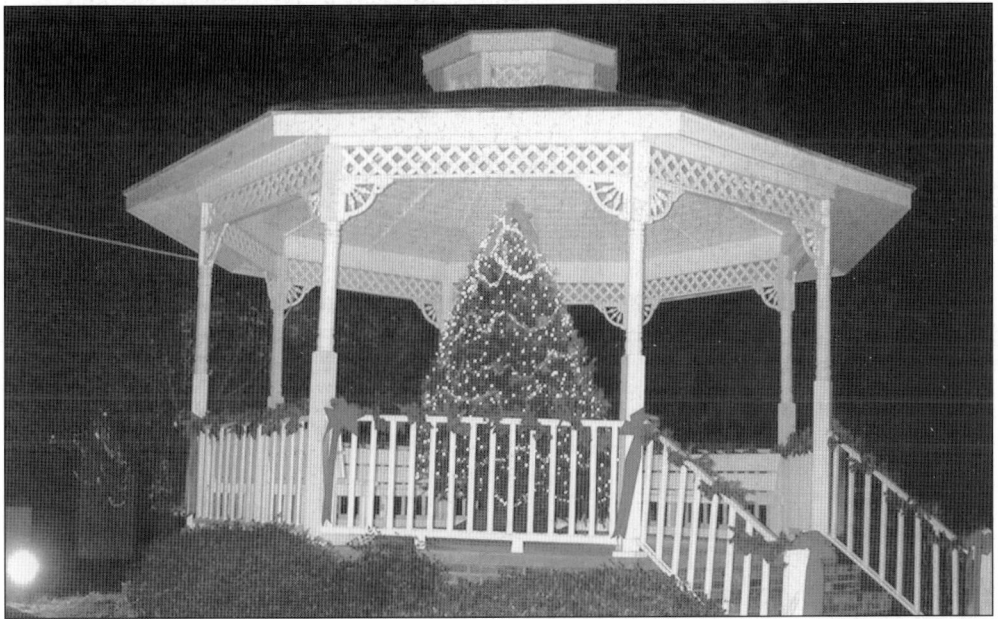

Pass Christian's gazebo in Memorial Park is the city's logo landmark. It is there that the Christmas tree is lit, announcing the arrival of Santa Claus. Nearly 1,000 visitors and locals gather for the evening's entertainment before dusk.

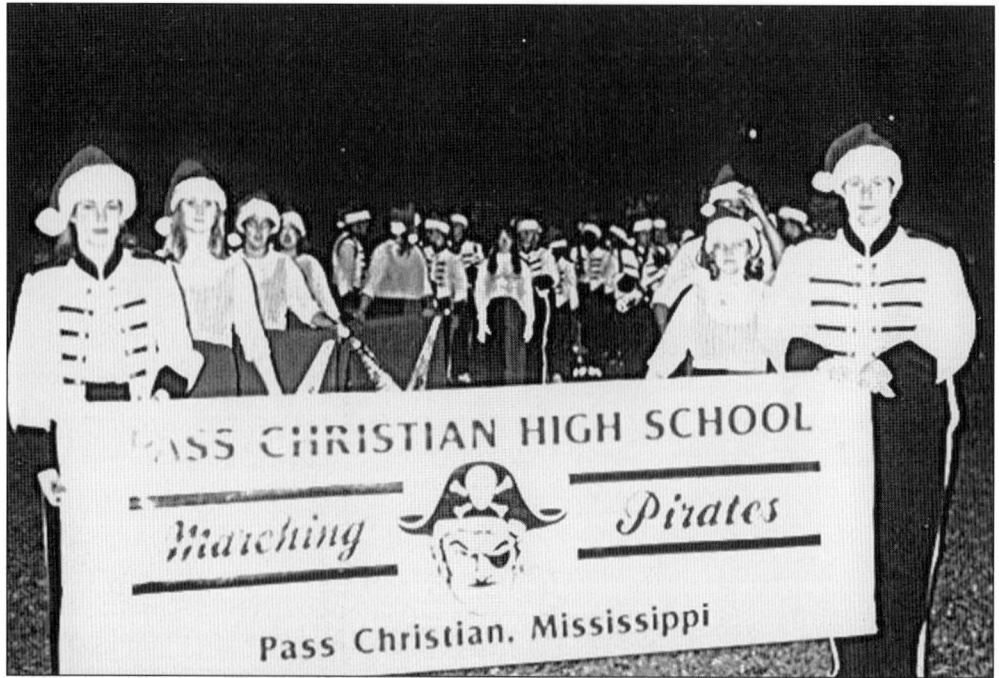

The high school band also performs at the Memorial Park. The band awaits Santa in order to begin the parade that proceeds along the Pass's famous Scenic Drive.

Hundreds of children mill around the park in anticipation of Santa's arrival while the elementary and middle school choirs sing out merrily and are joined by the crowds.

The crowds cheer as Santa arrives in his sleigh drawn by illuminated reindeer. Tradition has it that Santa dismounts from his vehicle to lead his many elves in passing out peppermint canes to the waiting children. The mayor of the town then greets Santa and together they light the Christmas tree.

St. Paul's Catholic Church keeps its doors open as choral groups perform the *Messiah*. In front of the church a large nativity scene is displayed for the holiday season.

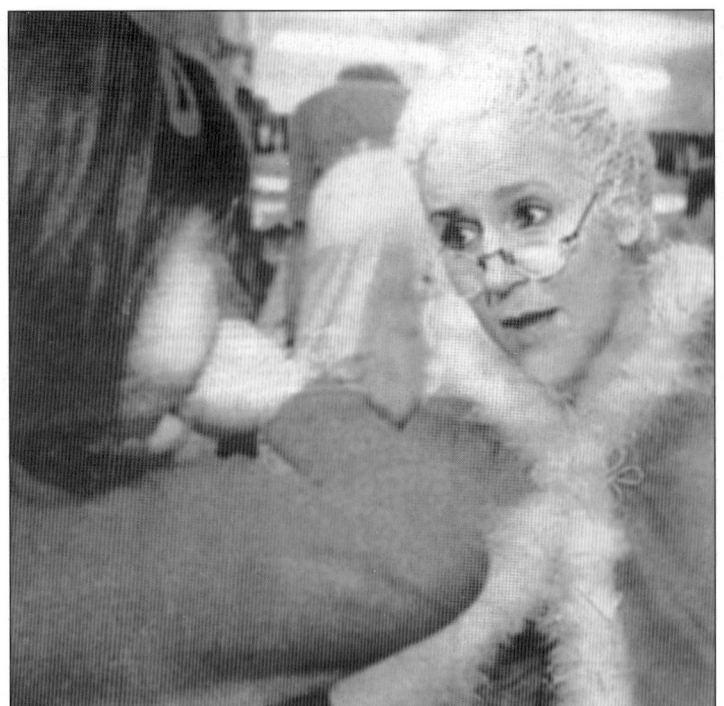

Mrs. Claus is a great hit with the children of the Pass and welcomes them at the park and throughout the evening. Tracy Gordon Goff makes Mrs. Claus real to many youngsters as she gathers them to her lap.

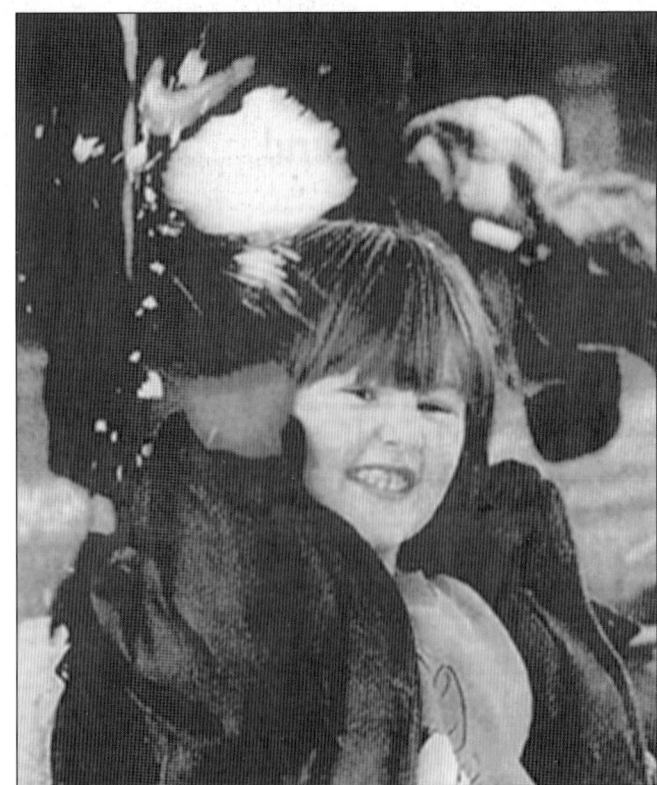

Snow was manufactured at the park for several years to give the kids a taste of a Christmas winter wonderland on the Coast. Little Elizabeth demonstrates her throwing arm by tossing a snowball at the hordes of children.

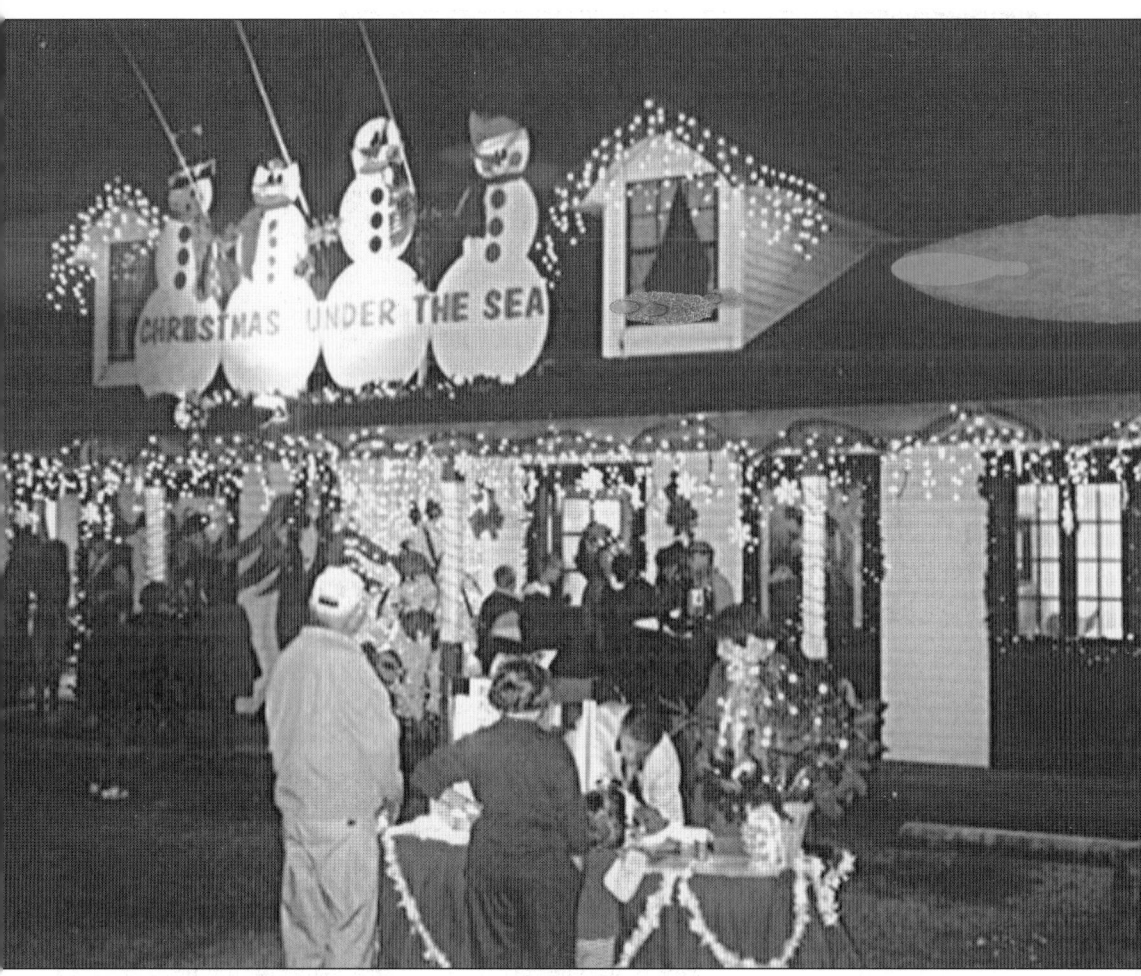

All of the Pass merchants decorate their businesses with lights and distinctive ornaments. Many offer beverages and light hors d'oeuvres and attract crowds with special entertainment such as music, clowns, rides, face painting, and storytelling.

A featured highlight of Christmas in the Pass is the "Lighted Boat Parade." The parade proceeds from the harbor and follows the Sound along the seawall that borders the sandy beach areas. In this view, approximately 15 vessels are decorated for the season.

Many events draw a large crowd to the city and visitors have to park their cars at a great distance from the main staging of events. Hiring special buses to transport people back and forth solved this problem.

Two

COMMUNITY HERITAGE

Pass Christian is known as the birthplace of yachting in the South. The first Gulf Coast Regatta was held in July 1849 and was promoted by the manager of the Pass Christian Hotel.

On the eve of that first regatta in 1849, the South's first sailing club, known as the Southern Regatta Club, was organized. The following day was a gala event at the Pass, and the usually quiet harbor was thronged with boats, gay with streamers, and manned by athletic crews.

In 1850, the sailing club was officially organized with Thomas Dabney as its first president. This was the forerunner of the Southern Yacht Club at New Orleans and the later Pass Christian Yacht Club that was formed in 1893 by Mayor Sam Heaslip.

Regattas were held at all of the cities along the Mississippi Sound and at New Orleans's Lake Pontchartrain. Each city took a turn as the event's host, inviting all the clubs to compete in special regattas.

Early shipbuilding at many locations along the Gulf Coast included some shipyards that were located on the bayous and rivers of Pass Christian and at DeLisle. Some shipbuilding still takes place in the area.

39

Because Lake Pontchartrain was not ideal for sailing and attracting spectators, most of the early racing sailors found the waters of the Mississippi Sound more to their liking. Many completion races began to take place between coastal cities, which gave rise to the construction of many hotels in these towns.

Competition between large schooners was always a thrill to see. Re-creations of racing vessels and competitions of the past still take place today. These beautiful full-masted ships with wind-blown sails are just as majestic as they have ever been.

The Gulf waters are famous for the great quantities of marine life that keep commercial boats working year-round. Boats move in caravans as they trawl the waters for shrimp.

The shrimp nets are full of shrimp and varieties of fish that are caught during the trawling action. The nets are emptied in the boats and are culled out from the catch and sorted by sizes.

Capt. John McDonald was well known in the Pass, having held many political seats. He also captained his own schooner and caught this huge sea bass, weighing in at 440 pounds and measuring more than 8 feet long. McDonald held the national title for many years.

Oyster schooners have been trawling the many nearby reefs for more than a hundred years. The local canneries that became prevalent in the early 1900s owned these schooners.

The Dunbar Dukate Canning Factory at the Pass operated between 1902 and 1947. Many shuckers at the plant were brought in from Baltimore and housed in factory rowhouses during the packing seasons.

The Dunbar Dukate Cannery also maintained 10 large schooners manned by their own crews, as well as more than 150 local independent oystermen to keep the cannery in full operation. Some fishers are shown here waiting their turn to unload at the rear of the factory.

The cannery pier extended out from the harbor and transported oyster sacks that were loaded on rail cars and pushed into the factory. To keep the schooners trawling, barges were sent out to the reefs to unload the oysters and replenish the schooners with ice and food supplies.

The Dunbar Dukate Cannery was not rebuilt after its complete destruction by a severe hurricane that hit the Gulf Coast in 1947.

In the 1930s, John Parker, the son of a former governor of Louisiana, was always seen casting his nets for shrimp or wading out in the shallows to cast for mullet fish.

This 1929 aerial view shows a Pass Christian harbor without levee protection. As the years passed, the Dunbar Dukate Cannery created a small island of oyster shells that reached out to the beach along the downtown district.

The Pass Christian harbor marina is considered one of the most beautiful along the Gulf Coast and is visited by many tourists.

The Pass Christian Harbor berths commercial boats of all sizes. A Lafitte Skiff is shown maneuvering the quiet marina recesses.

A 1960s aerial view shows the harbor marina and Henderson's Point at the top of the photograph. The harbor has taken different shapes as a result of normal expansions and storm destructions.

In 1969, Hurricane Camille completely destroyed the harbor, the nearby Yacht Club, and the downtown area. The harbor, bare of boats, is shown at the top right. The building at right, just off-center, is the old city hall that has since been replaced. This photograph was taken after all of the 10-foot-high piles of debris were removed.

Following the great storm destruction of 1969, the harbor and marina were reconstructed with 350 slips with varied berth sizes. Almost 1,000 linear feet of public fishing area is allowed on the two breakwaters that enclose the harbor entrance.

Pass Christian's harbor facility for commercial fishers consists of several packing plants that purchase oysters and shrimp from the fishers as they unload at the dock area. This photograph shows sacks of oysters being unloaded from a ship and stacked for transport to inland packers.

Pass Christian is famous for its December dawn. The Harbor Marina is in the backdrop of this photograph.

Bayou Portage is located on the north side of Pass Christian and empties into the Bay of St. Louis; two tributary streams also flow into the bayou. Many pleasure fishers seek out the varied freshwater fish that are found in these waters.

Bayou Portage and its tributaries also offer wonderful spots for water skiing and personal watercraft jockeying in cool flowing streams.

In 1924, seawall construction was begun at Henderson's Point and eventually extended along all three of the Mississippi coast counties. The seawall changed the contour of the coast by closing and filling in many small streams and bayous that emptied into the sound from inland origins.

When the steep seawall was completed, it greatly reduced the damage to homes along the beach road. However, it was found that the force of the wind-driven waves could break the wall itself.

Early roads were first covered with oyster shells. The main road fronting the beach was called Front Street, then First Street, and later Beach Boulevard. When automobiles were first brought to the Pass on railroad flatcars, a speed limit was established at eight miles per hour.

Natural, sandy beaches were held back from blowing across the roadways by wooden fences bordered with wild brush and trees prior to the construction of the seawall. Seawalls were erected in the 1920s and a four-lane highway was laid out in 1958.

This street scene from the 1940s shows the old city hall at right and a service station (that no longer exists) on the left side of what is today called Scenic Drive. Past the old city hall were several beer saloons, but as of 2000, only two taverns remained open.

The Northrop Building on the corner of Front Street and Davis Avenue was a general store, which later became the Idlewald Hotel. Behind the Northrop Building was the Hancock Bank of Bay St. Louis, which opened its first branch office in 1902.

The Hancock Bank constructed this building on the adjoining rear lot facing Davis Avenue and continued its banking operations from 1905 to 1928. This building remains a commercial office annex.

The Hancock Bank Building of today was built in 1928. It is prominently located at the corner of Scenic Drive and Davis Avenue and has retained its entire original interior throughout the years.

The Sperier Bar was located on the corner of Second Street and Market Avenue. Although it survived the ravages of Hurricane Camille, it could not survive the demands of the Health Department and was forced to close. It was later razed for being unsightly and a health hazard to the community.

The Town Library was the first library established along the Coast between Mobile and New Orleans. First opened by the Library Association in 1893, it was operated in various storefronts. The association bought the nearby 1849 cottage in 1905 and moved it back from the street curbing.

The largest hotel of great significance to the Pass was the Pass Christian Hotel, which had its beginnings in 1831 and grew in size as well as in popularity. It was from these quarters that Southern yachting was born. The hotel closed with the onset of the Civil War and afterward became the Christian Brother's College. It burned down in 1877.

At the site of the Pass Christian Hotel, the New Magnolia was built and remained a successful hotel until it also burned in 1915.

Because the New Magnolia's location was high on a ridge and close to the downtown section, the Miramar Hotel was built on its ashes and remained there until it was razed to make room for the present Miramar Nursing Lodge.

The Crescent Hotel is the only extant building that continues to be operated as a bed and breakfast now called the Harbour Oaks Inn. Built in 1860, the structure was originally called the Live Oak House. With the building that also still remains to its right, the Crescent Hotel provided 50 guest rooms.

Before the introduction of the railroad in 1852, the excitement of newly arriving tourists and friends was constant along the several long wharves that extended out to the Mississippi Sound. Once the train depot was built, however, most newcomers arrived as train passengers. This became the new nerve center for Pass townsfolk.

Arriving passengers could be taken swiftly by tally-hos to the Mexican Gulf Hotel that was located on Davis Avenue and the beach. Built in 1882, the hotel went through various changes of management and renovations.

The Mexican Gulf "Watering Place," as hotel locations were called at that time, was very particular about hiring chefs from Europe. Some of the best employees were imported and were provided with housing in the hotel cottages in order to be close at hand.

In 1894, the 250 guest rooms were renovated with lighting and heating. Under new ownership, the hotel it became known as the New Mexican Gulf Hotel in 1915. It was updated in grandiose fashion only to burn down in 1917 before even opening for business.

The Grey Castle Hotel was located on the eastern side of town. In 1923, wings were added on to each side of the building to provide more guest rooms and a more elegant facade. The hotel became a Catholic retreat home in 1929 and was called Xavier Hall.

The Brogan House, pictured above, no longer exists but is a typical example of the summer houses built along the beaches during the antebellum period. They were built by Orleanians who sought to escape the heat and crime that existed in their hometown.

The first summer homes were built as single-story Creole cottages that had gable roofs and three or more bay windows with inset galleries. Two-room cottages with nogging construction enveloped by foot-thick, double-brick exteriors and plastered inside and out were typical.

A ridge fronting the beaches of Pass Christian allowed most of the early houses to be built close to the shore. At the lower elevations, the houses were set back for protection from the storms that were subject to arrive during August and September. The earliest homes also included estates that covered the land fronting the beach and continued inland for a half-mile or more.

Seen here is the Pescud House, which no longer exists. Like most cottages built at that time, it had a long pier that reached 100 or more feet into the Sound. Small, private huts were built at the end of each pier, which served as bathhouses for swimming and as a place for boats to be tied.

As more wealthy Orleanians arrived, homes were renovated or added to, as in the case of the Dixie White House; it was raised to two stories with added galleries. The first of a string of presidents to stay at the Dixie White House was Woodrow Wilson, who spent time there during the winter of 1813.

An esteemed longtime educator, Adelle Bielenberg, dressed in her antebellum gown, is driven by carriage to the Dixie White House during one of the early spring pilgrimage re-enactments.

The elegant Ossian Hall, dating from 1849 to 1869, was built as a Greek Revival–style, plantation-type home. Between 1849 and 1850, 60 new cottages were built along the Pass's beachfront.

This beautiful house and estate was located on the west side of the Pass. During the 1920s, the house was increased in height when tall, white columns were added. But because it lay on lower ground, the home was completely destroyed by Hurricane Camille in 1969.

Jean Hardin painted her remembrances of what the Pass looked like when she was a child in the 1930s. This painting gives newcomers a rough idea of what the Pass once looked like.

Maps of the 1850s show hundreds of piers, like the one seen here, jetting out into the Sound. With indoor plumbing, people no longer need to make the long walk out to the bathhouses that were located at the end of the pier.

Piers are still used for fishing and tying up boats, but not as much as they once were.

The view from a home on Scenic Drive shows one of the many live oaks that shade the boulevard. Only the sandy beaches, a jetting pier, and the distant sails that dance on the waves break up the watery view.

The lonely, small pine tree that rises into the sky will provide its own shady view of the Mississippi Sound in a few years.

Promoted during the early to mid-1900s were the Middlegate Japanese Gardens located on Pass Christian's Highway 90. The Rudolph Hechts family had originally developed a love for Oriental culture on their frequent visits to the Land of the Rising Sun and brought much of that culture home to their Middlegate estate.

The most interesting feature of the Japanese gardens was the gigantic bronze statue of Buddha, which was imported from the famous gardens of the great Daibutsu in Kamakura, Japan. This Buddha still remains and is recognized as one of the largest in the world as it sits majestically upon a 20-foot pedestal.

Camp Kittiwake, which means "where the sea winds blow," was designed as a girl's camp with a Gulf shore frontage of 337 feet. Opened in the spring of 1938, the 12-acre campgrounds had five large log cabins to accommodate 100 girls. Besides a fresh artesian water pool on the front lawn, there was a long pier that extended out in the Gulf with a "U" dock at its end.

Beginning in the late 1940s, Camp Kittiwake offered a boys' camp as well as a girls' camp on different schedules during the year. There were sailing crafts, rowboats, and canoes, and campers could also bait crab traps to catch fresh seafood. At evening campfires there were group sing-a-longs, skits, and barbeque cookouts.

In 1955, the Kittiwake campsite was taken over and used as the Mississippi Baptist Assembly Center. It was a viable 12-acre site fronting the Gulf with many amenities for a Christian Youth camp. Immediately available were ten cabins, two tennis courts, a swimming pool, manager's home, faculty residence, and a main assembly hall that included an auditorium, assembly rooms, dining room, and a kitchen. Initially the facility was used for summer vacations with educational, inspirational, and recreational programs for Baptists. With the move to Henderson Point on the west side of Pass Christian, the Assembly Center was able to add even more youth-oriented programs. Situated on that site now are large modern homes, each with a view of the Mississippi Sound.

The Pass Christian Lighthouse, built in 1831, was the first construction of a Mississippi mainland light tower. A sister tower of similar architecture was also built on neighboring Cat Island. The Pass Light went out of commission in 1882 and was sold at auction. Today, its former location is the site of the Pass Christian City Hall.

A Pass Christian Lighthouse Society was formed with the intent of reconstructing the light near its original location. An architectural model shows how the lighthouse and keeper's house would have appeared in the mid-1800s.

73

The Merrills's Shell Bank Lighthouse was a later replacement for the Cat Island Light, which was discontinued in 1937. The Merrill's Light is also known locally as the Pass Marianne Lighthouse and is located directly south of Pass Christian.

Murray Rabelais is shown with his model of the Pass Marianne Light. Since retiring, Murray has reproduced a number of the Gulf Coast light towers.

Bathing belles of the past were lined up on the front lawn of a home facing the beach. Pass Christian is famous for its water sports and beaches.

Each year, the "Spring Fiesta" and the "Tour of Homes" inspires a number of hostesses to dress up in full antebellum gowns. They welcome visitors to the Pass and also help serve at the formal teas that are held in one of the large beach homes.

Believed to show members of the "Smoker's Club," this group photograph was found in the attic of one of the old homes of the Pass.

A successful squirrel hunt always provided great sporting entertainment for the menfolk, as can be seen in this 1893 photograph. The hunt took place in the Honey Island swamps near Pearl River.

Town leaders of 1937 assemble in the boardroom of the old city hall. Seated at the right of the table is Mayor J.H. Spence, while the others pictured are aldermen and city administrative staff.

Charles M. Rhodes was mayor in 1895 and was one of the first post–Civil War merchants at the Pass, having arrived in 1879 when it was stated that "all roads led to the Pass." Seasonal enterprises that made the Pass famous included its cotton trade, wool market, and the continued arrival of thousands of tourists.

Mrs. Catherine James was the last librarian to keep the private non-profit "Town Library" open for public use. Mrs. James clipped newspaper stories about the Gulf Coast and enclosed them in many pertinent books that are still stored in the closed library. Since 1893, hundreds of first draft books were presented to the library by authors who came to the Gulf Coast to write.

The McKay family kept the local news posted in one of the longest-running weekly newspapers on the Coast, the *Tarpon Beacon*. The man-and-wife team were always seen around town gathering newsworthy items.

Lucien Piernas was the affable and courteous longtime bartender at the Pass Christian Yacht Club. He was known for always introducing newcomers to the local folks who gathered at his bar seats.

Some of the largest live oak trees in Mississippi grew around Pass Christian. Until 1950, this tree was called the "King of Oaks" in the South. It was located at the east side of the downtown area and spread its limbs over the whole field. This photograph shows a man and carriage near the right side of the trunk base.

The hallmark of the Pass is its gazebo in Memorial City Park, which fronts the beaches and shore. In the rear end of the park are 13 majestic live oaks, all of which are listed with the National Registry and were memorialized with the names of presidents.

Pass Christian Isles Golf Course was organized in 1952 and most players consider the 18-hole professional course very challenging.

The lush greens of the golf course make a beautiful setting for the homes that have grown up around them since the 1950s. The golf club gives an ambiance of country club living to the Timber Ridge subdivision, which abounds with canals and natural bayous.

The Oaks is a new golf course in the Pass, where the Mississippi Gulf Coast Open Tournament was held in 1999 by Nike and in 2000 by Buy.Com. This player successfully putted at the number twelve hole.

The Oaks of Pass Christian is described as a "fast golf course," meaning that the ground is hard and requires accuracy when teeing off.

The Harbour Oaks Bed & Breakfast acquired the only extant hotel in the Pass. The former Live Oaks and later Crescent Hotel dates back to the 1850s.

The Inn at the Pass is the second bed and breakfast available in the Pass, where there are no provisions for hotels or motels located on the city's beachfront.

83

In addition to the two existing nursing lodges is the beautiful Twin Oaks assisted-living complex, located just off the beach area. It affords a professionally operated and healthful environment for the aging population.

A new city hall was built in 1970 and dedicated to the Hurricane Camille victims as a memorial. The one-story, columned building faces the municipal harbor and is situated on the former site of the Pass Christian Lighthouse.

Internationally famous jazz saxophonist John Handy started playing music early in his life. In his hometown of Pass Christian, Captain Handy was born into a musical family—his father started the first walking band; his mother played the piano; a brother played guitar; and a sister played the violin.

Capt. John Handy started as a drummer and, by age 14, was versatile on various instruments. After going to New Orleans, he became a top-notch clarinetist and later became one of the first alto-sax jazz musicians. In the later years of his life, Handy was often found playing at the famed Preservation Hall in New Orleans.

Captain Handy's band in the early 1920s was called the Louisiana Shakers, but he also sat with a number of other bands, including Kid Sheik's Storyville Ramblers, which he joined during the band's tour through Japan.

On tour in Europe, Capt. John Handy and Lionel Hampton are presented with gold medals in Italy. Only late in his life did Handy make some special recordings that captured his favorite jazz tunes for posterity. Some contemporary artists with whom he shared a friendship were Louis "Satchmo" Armstrong, Mahalia Jackson, Duke Ellington, Cab Calloway, and many other well-known musicians.

Handy was born in 1900 and died in Pass Christian in 1970. He actually had two funeral observances, one in New Orleans for all of his friends there and another in his hometown of Pass Christian. His funeral was the first New Orleans–style jazz memorial to hit the Pass, as more than 7,000 people joined the procession from the church to Handy's gravesite.

87

Another famed jazz musician from Pass Christian was Joseph "Joe B" Jackson. As a pianist, Jackson played mostly with bands that performed along the Mississippi Coast and in New Orleans. He also formed his own band known as "Jobie Jackson's Band."

A member of the Watson Boys, Eddie Watson often played with Captain Handy's Louisiana Shakers. Watson was a guitarist from Pass Christian who played in his brother's band and also sat with other groups from the 1920s through the late 1950s.

Three

HISTORIC DISTRICT

Welcome to Pass Christian and its Historic Preservation District. Following the extensive devastation by Hurricane Camille, citizens became concerned for the loss and possible willful demolishing of the city's remaining historic structures. This resulted in a handful of concerned beachfront residents submitting nomination forms to the National Register of Historic Places in 1979. Due to their efforts, the historic district became a reality and helped to preserve many homes and the heritage of one of the single-most intact heritage districts in the United States. The essence of Scenic Drive and other parts of the beachfront district are now protected from uncontrolled housing developments and by destructive renovation constructions.

The Tessier family built this picturesque, two-story frame dwelling in 1895. Renovations and additions were made in 1986, including the double-tiered gallery that is set with fluted Tuscan Ionic columns.

This two-story frame, hip-roofed, Colonial Revival dwelling is known as the Breaux-Clay House. From the center roof projection, the home is appointed with a projecting thermal windowed dormer. The structure was expanded with a porte-cochere on the east and a two-story addition on the west side.

Known as the Legier-Frye House, this two-story, Colonial Revival bungalow was built in 1910. The home is one of the most architecturally progressive dwellings on the beach. An earlier pedimented, one-story frame cottage with square-columned inset gallery remains on the property.

Known as the Seaton-Davis House, this distinctive, one-story, vernacular dwelling was built in 1850. Robert Seaton and his architectural partner James Gallier built Gallier Hall, which is the old city hall in New Orleans.

This two-story, hip-roofed, Colonial Revival cottage is accented with a double-tiered gallery supported by Tuscan columns. It was built in 1900 and was extensively remodeled in 1986.

Known as the McCutchon-Ewing House, this handsome, hip-roofed, Greek Revival dwelling was raised to two stories in 1938. Its arched arcade supports an impressive flat-roofed portico, which is set with square columns. When originally built by Percival McCutchon in 1850, it was named Carlisle Place for his hometown in Pennsylvania.

This two-story, hip-roofed, Colonial Revival dwelling was built in 1890 and was named Whitehall. Its first level piers are of brick, and the second level is set with Tuscan columns with a turned balustrade. Adjoining the main house is a small cottage that was possibly built in 1840.

This two-story, hip-roofed, mission-style dwelling was built in the 1920s and owned by Justin and Drucilla Courtenay. It has a three-bay, double-tiered, stilted arcade with an inset gallery that dominates the frontal facade.

Dating from the 1850s, this handsome dwelling was originally built as a story-and-a-half, five-bay, coastal cottage. The gallery with square columns wraps around three sides of the house. The home is noted as the most significant antebellum house on the western portion of Pass Christian's beachfront. The interior was completely and richly renovated in 1999.

Built in 1860, this two-story, gable-roofed, coastal cottage has a double-tiered inset gallery with giant-order square columns. During the 1880s, this residential building was incorporated into the Crescent Hotel complex.

Earlier called The Belvedere, this majestic mansion is a lavishly detailed two-and-a-half-story, Colonial Revival dwelling. Built in 1909, the home has a giant-order, flat-roofed portico and end pavilions with an interior plan that adds gracious continuity to the home.

The Marks family built their home called Seagulls in 1871. The original, first-level columns were replaced with brick arches in the 1930s. Following heavy damage caused by Hurricane Camille, the home was restored with careful detail, even to the fluted Corinthian columns, turned balustrade, and bracketed cornices at the gable ends. Architecturally, the home is one of the most distinguished structures in the Historic District.

This large, two-and-a-half-story, Colonial Revival house was built in 1964 on the site of two former antebellum homes. The Georgian-style home is located on an 800-foot trace that is comprised of 8 acres. This 30,000 square-foot residence is noted as the largest house in the State of Mississippi as a result of the expansions that were made in 1997. Its wide and spacious grounds are elaborate with landscaping and abundant trees.

Known locally as the Union Quarters, the core of this old mansion was first erected in 1848 by Philip Saucier, a descendant of one of the French settlers of 1699. After the Civil War, Union officers were billeted here. Through the years, each new owner renovated and expanded upon the previous structure, while maintaining the beauty of the home's architectural design. This photograph shows the mansion in holiday decor.

Four

HURRICANE CAMILLE

After being up all night, Civil Defense Director Parnell McKay inspected the damage done by Hurricane Camille after it hit the Gulf Coast on August 17, 1969 and targeted Pass Christian as its primary focal point. Of the 131 coastal death casualties, 78 were singled out from the small city of the Pass. McKay surveys what remained of the old city hall.

Hurricane Camille's frontal attack was followed by a 25-foot tidal surge that washed across the entire breadth of Pass Christian, tearing down commercial buildings, uprooting live oak and pine trees, splintering telephone polls, and eliminating many of the antebellum homes that had endured previous storms.

Hurricane Camille rendered full destruction upon the Dixie White House, where a number of past presidents of the United States had been entertained. This site is now barren ground guarded only by a historic marker that remains as a symbol of the famous home's prior existence.

Second Street, or Back Road as it was called in the 1850s, became the catch-all for debris that was shoved from the beach properties by the pounding waves. A tilted telephone pole is wrapped with the metal roofing from a nearby building.

The Louisville & Nashville railroad line is shown on high ground with hurricane floodwaters on each side. Only about half of the city's residents were able to evacuate prior to the onrush of the 200-mile-per-hour winds and immersing tidal waves.

Hurricane Camille tore the roofing from one of the most historic homes, Union Quarters, which was named for the Federal troops who occupied the town during a Civil War skirmish. This home has since been completely restored. The original portion of the elegant mansion was built in 1848.

Hurricane Camille tossed ships and small vessels that were left moored and unprotected at the Beach Harbor. The *Frances* was found on the highway's high ground median the day after the "Big Storm."

Hurricane Camille had completely demolished the small downtown area of Pass Christian, showing disregard for buildings, trees, poles, and automobiles as they were all piled in stacks 10 to 20 feet high along Scenic Drive.

Hurricane Camille left its mark for many years afterward, causing many out-of-state homeowners to slowly sell their demolished properties. New owners were challenged to restore, or to build anew, a more formidable beachfront while maintaining the integrity of Pass Christian's impressive 300-year history.

Highway 90 was strewn with debris 10 to 20 feet high. The 25-foot tidal surge crushed houses and cast its victims afloat upon rooftops that were pushed for several miles.

Five

CHURCH AND SCHOOL

In 1977, the Rev. Joseph L. Howze was appointed bishop of the newly established Diocese of Biloxi. He is the first African-American bishop in Mississippi to minister to the growing numbers in parish schools and churches.

This second Catholic church in Pass Christian was built in 1879; it replaced the first structure, which was built in 1851 and burned down in 1876. Father Henry Georget dedicated this new church to St. Paul.

A third St. Paul's Church was erected in 1920 but was razed following Hurricane Camille, though it suffered very little damage. The church was scheduled for replacement due to the growth of the parish.

St. Philomena's Catholic Church was built in 1911 as a result of the St. Joseph's Society's decision to create mission churches for the growing numbers of African Americans in Catholic parishes along the Gulf Coast.

St. Philomena's Parish members assemble for this 1920s photograph in front of the church steps.

St. Philomena's Church was renamed Mother of Mercy Catholic Church just a few years after celebrating its Golden Jubilee in 1961.

Rev. Thomas R. Savage supervised the building of Trinity Episcopal Church in a Gothic style of architecture. He performed the first services in March 1850.

Hurricane Camille swept away all of the church edifice and the rectory, where 13 members of the Williams family died while taking shelter in the sanctuary. The church has since been rebuilt.

There were a number of one-room schools before the local public school system had this building constructed in 1891 at a cost of $1,250.

In 1904, there were 82 white students and faculty members that reported to school for this photograph taken on the front steps of the schoolhouse.

A new, brick school building was built on the site of the former Pass Lighthouse. The then-vacant public school building was torn down after Hurricane Camille to make room for the new Pass Christian City Hall.

The state-of-the-art Pass Christian High School was opened in 1999. It is capable of handling 750 students within its 82,000-square-foot structure that was built with funds derived from a $10 million bond issue used on local schools.

The Randolph African-American school had a long winning streak in athletic sports, as is demonstrated by this all-girl team.

With origins dating back to 1870, this school was once called the Sister's School and later became St. Joseph's Academy. It is now known as St. Paul's Catholic Elementary School.

Six

HENDERSON'S POINT

A 1952 aerial view of the western tip of the Pass Christian peninsula shows Henderson's Point at the southwest corner. Though unincorporated, the area sustains a distinction of being apart from and yet sharing in all of the history of Pass Christian. This view captures the seven miles of canals that were dug and dredged to make the newer subdivision called Pass Christian Isles.

In the early 1920s, the Drackett Ferry was commissioned to carry passengers and automobiles. However, the line was soon discontinued when, in 1928, a wooden bridge was constructed to cross the bay from Bay St. Louis to Henderson's Point.

Early automobiles crossed the bay on the Drakett Ferry during the 1920s. On weekends, bands played on the top deck and the younger crowd would dance the night away as they crossed back and forth.

In the early 1920s, land promotion of the prime Henderson Point location was further developed with a grandiose and luxurious Mediterranean-style hotel named the Inn-by-the-Sea. Cottages were also built and snuggled beneath the many moss-hung live oaks for awaiting guests.

The Inn-by-the-Sea attracted tourists from northern states as well as nearby cities such as New Orleans.

Promoted as a Gulfside Riviera, the Inn-by-the-Sea had a bell tower that overlooked the Bay of St. Louis and provided a spectacular view of the wading pools and manmade lagoons that harbored many varieties of exotic fowl.

A Spanish-style cloister opened on to the courtyard where many of the hotel guests were served breakfast while the summer sea breezes brushed the heat away. Unfortunately, the Depression of the 1930s caused the hotel to close its doors.

The closed Inn-by-the-Sea hotel complex was an ideal location for the placement of a merchant marine school at the breakout of World War II. Many of the buildings of the former hotel were converted to classrooms and administrative offices, and new barracks-style buildings were erected as dormitories.

The U.S. Merchant Marines Cadet Corps Basic School used the Inn site from September 16, 1942 through March 21, 1950. More than 6,000 undergraduates were trained there and at its sister school in San Mateo, California. Remembrances of former graduates were never lost as many of them frequently return to visit.

In formation, the merchant marine cadets march in their whites to receive their graduation certificates before going on to the U.S. Merchant Marine Academy at Kings Point, New York, where they will receive further training before being shipped out for sea duty.

The complex was acquired in November 1958 by the Baptist Assembly of Mississippi and renamed the Gulfshore Baptist Assembly. This 1960s aerial photograph shows the religious compound before it was almost totally destroyed by Hurricane Camille in 1969.

A new campus with new buildings took time to be constructed out of the ruins left by the Big Storm. The complex was finally rededicated on May 9, 1978. Gulfshore Baptist Assembly primarily exists for the training and promotion of missionary, evangelical, and educational works established by the Mississippi Baptist Convention.

The three-story Administration Building encompasses more than 171,000 square feet with sleeping accommodations for 250 people, a large, cafeteria-style dining room, and 26 modern classrooms. Another building on the campus includes a 750-seat auditorium.

The sea wall that extends across Harrison County began its 27-mile stretch at Henderson's Point in 1924 and continued eastward to Biloxi Bay. In the 1950s, the stepped sea wall was further reinforced by a wide band of pearly white sand that was dredged from the Mississippi Sound, making a large beach playland all along the coastline of Highway 90.

Twin pines in the form of a huge lyre were located on the beach area of Henderson's Point in the 1920s. The trees have since been lost in storm action. Deborah Hewes, shown in this photograph, was one of the descendants of Elliot Henderson's wife.

Known as Bentley's, this Henderson Point restaurant was built in the 1920s on the main roadway to Pass Christian. It was also a night club and tavern that accommodated some gaming tables and slot machines in the casino room.

Known as Benny French's Tavern, this facility was also a nightclub, restaurant, and gaming casino during the heyday of the Mississippi Coast's "Gold Coast" reputation—before the 1950s shut down of illegal gambling. It has continued operations as Mallini's Tavern.

Henderson's Point provides a beautiful vista for condos and apartment complexes that have been constructed along a section of its beaches.

A new overpass recently replaced an older crossing to provide a free flow of automobile traffic across the Anchorage Bayou and railroad tracks beneath.

Seven

DeLisle on the Bayou

Bayou Portage is the northern boundary of the City of Pass Christian. Crossing the bayou is a cement bridge, which leads to the small town of DeLisle just four miles north of the Pass. During the late 1700s and early 1800s, DeLisle, then known as Wolf Town, was actually more heavily populated by settlers than was early Pass Christian. The whole peninsula of Pass Christian was owned by just one person at that time.

Passing along the south end of DeLisle is the Bayou DeLisle from which the town derived its name. Another water stream known first by its French name, Riviere des Loups, is now known for its English name, the Wolf River.

A large cluster of aging live oaks, known as the Dedeaux Oaks, is spread upon the banks of Bayou DeLisle. During the late 1800s and early 1900s, the town was known for its shipyards and lumber industry as well as the kilns that regularly produced "Moonshine" or "Creme of DeLisle."

The inset photograph shows Father Sorin, who, in 1905, built the Catholic church at DeLisle that was called Our Lady of Good Hope. In addition, Father Sorin built many mission churches in the surrounding area.

During his many years of serving the DeLisle area, Father Sorin traveled to each chapel and mission by way of carriage in his quest to save new souls. He was also well known for the many religious songs that he composed and that were published by the Diocese of Biloxi.

The cemeteries at DeLisle are divided between the old section and the newer sections. The old cemetery on the banks of the bayou contains of all the first French settlers names as well as the new arrivals that came to the area after 1815.

During the early 1900s, the DeLisle schoolhouse consisted of four classrooms, two grades to a room, from first through eighth grade. An auditorium was later added before the facility was designated for elementary use.

The former African-American St. Stephens Church at DeLisle has survived to become the official Catholic parish church. Following the 1969 hurricane destruction of the all-white Our Lady of Good Hope Church, the African-American congregation opened its doors in welcoming fellow Catholics. In this photograph, Pastor John Ford, a Trinitarian priest, is shown talking to one of the nuns.

New additions to the DeLisle Elementary School were added in the year 2000. Replaced were the old cafeteria, library, and auditorium, and a new gymnasium was added. The old rooms were refurbished, bringing the total to 14 classrooms.

This vacant gas station is a remnant of the commercial activity that once existed in DeLisle. Residents now drive to other parts of the Gulf Coast to do their shopping and to seek recreation.

This county fire department facility, complete with modern firefighting equipment, replaced the older volunteer fire department.

During the summer of 1973, feasibility studies resulted in the formal dedication of the Dupont DeLisle Titanium Dioxide Plant facility on the Bay of St. Louis at DeLisle. The plant was constructed on a 200-acre site within a 2,000-acre buffer zone that was converted into a protected wildlife forest. This photograph shows the entranceway to the plant.

In 1984, Dupont purchased the adjoining 80-acre Pine Hills Hotel property. They designated it a "Good Neighbor" buffer zone to be used by Dupont employees as a recreation area. The hotel was completely dismantled, leaving only the brick-pillared entranceway visible here.

New Orleans and Northern bank investors developed the Pine Hills Hotel, which was located along the route that the first automobile traffic would have to travel on the northern shores of the Bay of St. Louis. This photograph shows the hotel under construction in September 1926.

The grandiose hotel was short lived as were many hotels along the Gulf Coast, and the Great Depression caused it to close. A number of years passed until the Pine Hills Hotel was taken over by the Oblate Fathers as a Catholic seminary. This retreat lasted until the hurricane of 1969.